£2.25

Modern Scottish Painters
NUMBER SIX

Robin Philipson

by Maurice Lindsay, for the University Press
Edinburgh

© Edinburgh University Press, 1976
22 George Square, Edinburgh
with the financial support of the
Scottish Arts Council
ISBN 0 85224 302 2
Printed in Great Britain by
W. and J. Mackay Ltd, Chatham

Title-page portrait from a photograph
by George Oliver

Preface

I first encountered the work of Robin Philipson through my friend, fellow poet, and original co-editor of BBC Scotland's radio magazine of the arts, 'Scottish Life and Letters'. 'There's a chap called Philipson', George Bruce said, 'we ought to get hold of. He paints cockfights'. 'Horrible,' I said, imagining scenes glorifying hunting by ben- and glen-artists of a previous age, 'positively barbaric. And besides, painters always talk in a jargon incomprehensible to ordinary, intelligent listeners.' Fortunately, ignoring my protests, George Bruce took me to meet Philipson. I was both astonished at the emotional impact of his painting–an impact, I at once realised, on the side of humanity–and charmed and delighted with the lucidity and elegance of his conversation. Since these distant radio days of a quarter-of-a-century ago, I have twice had the pleasure of talking to him on television while he astonished viewers with his dexterity. My admiration for his achievement has deepened with the years, as has the enjoyment of friendship. I therefore felt greatly honoured when the question of writing this book was under discussion and my name as putative author emerged out of talk between the Scottish Arts Council, Edinburgh University Press, and the artist, in the event my distinguished and co-operative subject. He has been a patient sitter, discussing readily his philosophy of painting, showing me slides of paintings that I might not otherwise have seen, and making suggestions to improve the text that follows.

In view of the circumstances surrounding that first meeting with Philipson, it was fitting that George Bruce should also volunteer to read my text, making several helpful comments. To both George Bruce and Robin Philipson I am deeply grateful. I owe my best thanks to Helen Logan, who wrestled with my handwriting to produce the first draft of the text and typed the final version.

I am also grateful to all those, acknowledged formally elsewhere, who have allowed works by Robin Philipson in their possession to be reproduced within these covers. The book, I hope, reflects my own belief that Philipson is not only an important painter of very considerable stature, but also a satisfying and enjoyable one.

MAURICE LINDSAY
Glasgow, January 1976

Publisher's Note. The publication of these monographs came about at the instigation of the Scottish Arts Council, which felt that, apart from sporadic articles and features in the press, art journals and exhibition catalogues, there was a dearth of critical and biographical material on contemporary Scottish artists. These books are, therefore, an attempt to provide definitive, well illustrated, critical and expository studies, which will not only communicate the peculiar excellence of each artist but also analyse their work in the light of twentieth-century Scottish painting, and indeed in the wider context of European art as a whole. In this way it is hoped to promote a wider acquaintance with the work of those artists and, perhaps most importantly, to stimulate the reader, who has not already had either the inclination or the opportunity, to look whenever possible at the actual paintings. To this latter end a list of public collections and other public bodies owning works has been appended.

The University Press wishes to acknowledge the financial support and the general co-operation of the Scottish Arts Council, and to thank the following individuals for making freely available their time and expertise in collecting information about many of the paintings illustrated: Bill Buchanan, Gustave Delbanco, Christina Doctor, Harold Fletcher, Bill Jackson, George Oliver, Robin Philipson, Tom and Anne Scott, Philip Wright, and many others.

The publishers have made every effort to establish and locate the owners of paintings illustrated, and apologise to those concerned when this has proved impossible. They will be glad to receive notification of up-to-date information on this matter for any future editions of the books.

BROADLY SPEAKING, there are two approaches to art. The older approach relies upon objectivity, order, Apollonian restraint: indeed, is what is generally referred to loosely as Classicism. The newer approach, which stirred out of the eighteenth-century *Sturm und Drang* manifestations, is essentially subjective, less dependent upon formal considerations, Dionysian in its abandon: the Romanticism which swept through the arts in the nineteenth century, and whose effects are still active in the late twentieth century. Romanticism was not, of course, simply a product of those forces of spiritual and political unrest that led up to the French Revolution. Romantic feeling, though then, so to say, in a position of 'governmental minority', made itself clearly felt in the operas of Monteverdi and in Haydn's middle-period symphonies, as well as in the Apocalyptic pictorial visions of Hieronymus Bosch and the poetic revelations of William Blake. Even after the heady contagion of Romanticism had laid its triumphant hold upon man's imagination, occasional creative gestures were still made towards neo-Classicism, as in the early music of Poulenc and that of middle-period Stravinsky; through the poetry of Alan Tate and in the stylised urban painting of L. S. Lowry. Although Classicism, as I have loosely defined it, is probably unlikely ever again to hold total sway (except possibly for brief periods of ascetic reaction) the creative process nevertheless depends upon the interaction of these two basic approaches: upon tonal or verbal outward contrast, and the resultant inner tension.

Such an outer and inner tension of complementary opposites lies at the heart of the work of the painter Robin Philipson. This lithe, dapper, bow-tied artist, so full of voluble charm, who is apt to move about at a semi-run, and who claims to grudge every minute of his life that cannot be devoted to painting, is nevertheless the successful and inspiring Head of the School of Drawing and Painting at Edinburgh College of Art, President of the Royal Scottish Academy, an articulate broadcaster, and a conscientious and effective member of numerous public bodies as diverse as the Scottish Advisory Committee to the British Council, and a founder member of the Committee running that remarkable centre for the arts in the Royal Burgh of Haddington, the Lamp of Lothian Collegiate Centre. It is not difficult to see that, however much in one sense he may find such civic duties from time to time irksome, they tauten the tension round which his achievement as an artist has evolved.

His services to Scottish art, and indeed to Scotland,

have been both numerous and enthusiastic. Yet he is a Scot by adoption: one of that band of sensitive Englishmen who, in the post-Second War decades, felt themselves more involved with the cultural manifestations of Scotland's re-emergent sense of nationhood than with the culture of England, although unlike so many other adopted Scots, Philipson lived and trained in Scotland from an early age.

He was born at Broughton-in-Furness, in the county of Lancashire, on 17 December 1916. His mother, Agnes Postlethwaite, had lost her first husband, a farmer, and already had a family of three by him when she married for the second time. Her new husband was James Philipson, a village stationmaster in the employment of the London, Midland and Scottish Railway. Although Philipson senior was not a creative person in the artistic sense, and, according to his son, never had the chance fully to expand his personality in his job, he excelled in such organised activities as bringing together a St John's Ambulance brigade of railway stationmasters and signalmen good enough to win the English championship shield on several occasions.

Robin first went to school at Whitehaven, in Cumberland. There he remained even after his father had been moved from Whitehaven to the little town of Maryport, that now-deserted seaport with a silted harbour and comely little houses lining a main street, which tumbles itself down to the sandy Solway estuary. Even before his formal education began, he had found by the age of three-and-a-half a fascination for drawing on paper, or,

as he relates, 'on the meat-chopper board'. As soon as he was able to talk, he declared that he meant to be a painter.

When the future painter was fourteen, his father made his final move in the service of the L M S, to Gretna. It was not easy for Robin to get into Dumfries Academy at his age, lacking any obvious brilliance. His twin sister passed the entrance examination at a first sitting, but after three failures, her brother was eventually admitted. He still regards his arrival in Scotland as a piece of 'great good fortune', a view his admirers would certainly share. All the same, he had to overcome obstacles at Dumfries Academy: the fact that, in the eyes of his fellows, he was an 'intruder'; that he did not take first place in the Art class, and that he even failed his English examination. For his part, he analysed and found wanting some aspects of the teaching methods to which he was being subjected. He thus attributes to the unhappier side of his schooling his lifelong interest in educational methodology.

As his schooldays at Dumfries drew to a close he applied for admission both to the Glasgow School of Art and to Edinburgh College of Art. A day visit to the Edinburgh College, when the place was deserted except for a kindly janitor who invited him to look round, and his first sight of the building itself made him decide that this was the place for him. It was surely a wise decision, when one thinks that the group with which he became loosely associated included, among others, Anne Redpath, Sir William Gillies, Henderson Blyth

and Sir William MacTaggart, all of whom had connections with Edinburgh College of Art.

The Principal of the College at that time, Hubert Wellington, was a severe critic. Philipson recalls two incidents that suggest Wellington was well able both to avoid the danger of his students becoming swollen-headed, and to recognise ability and integrity when he encountered it. At one of Philipson's interviews with Wellington, the Principal's critique had been unusually severe. Soon after, at an exhibition of student work to be judged by him, Wellington came upon a portrait by Philipson: 'What a sad looking woman!', the Principal remarked. 'Who painted this one?' 'I did, Mr Wellington', Philipson said. 'My God!', Wellington retorted, 'No wonder she's a sad looking woman!'

His style of teaching was to make negative observations that in reality emphasised valuable points, a method Philipson calls 'planting an idea in someone's mind and wondering if it might explode', and one that he has since used in his own teaching. On the whole Philipson recalls his student days with pleasure, and thinks of his former Principal with gratitude.

After the 1939-45 war, Wellington was invited to give a lecture to the Society of Scottish Artists. Philipson saw him outside the building, and went over to thank him for the benefit he had received as a student. 'Philipson', Wellington said, 'Haven't you got your hair parted on the other side?'. The former pupil, astonished at such remembered perception, teased the Principal about making such a trivial observation. 'No', said Wellington, 'it is absolutely right that I do note these things.'

Other influences of different kinds were William Gillies, Penelope Beaton, who impressed him with the significance of shapes, and John Maxwell, whose drawing of a shell for Philipson's benefit taught him that you have to watch both the object and the drawing as it develops; that if you gave both the big spots on the shell and the little ones the same emphasis, then you did not have a statement. There was also the suave fluency of R. H. Westwater's painting, and the sheer virtuosity of David Foggie's pencil. To this day, Philipson stresses to his students his belief in the importance of being able to draw well as a fundamental discipline.

All these influences were eventually to find their place in the formation of his own style. But, of course, there were also the broader influences: locally, at first as a schoolboy, through the exhibitions of the Dumfries and Galloway Fine Art Society, which managed to embrace the work of artists as diverse as Maxwell and those latter-day Art Nouveau book illustrators, E. E. Taylor and his better-known wife, Jessie M. King (although Philipson deplored their tendency to be influenced by immediate, superficial things); from the past, the Della Francescans, for their geometric beauty and the cool elegance of their colour. After the war, there was the deliberately chosen master, Oscar Kokoschka, to be followed later by the influence of Max Beckman, de Kooning, and Soutine, among older living painters. The Kokoschka influence is perhaps the most

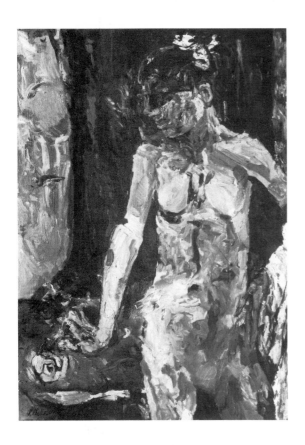

obvious. It is certainly apparent in such works as the early portrait of *Young girl with a rose* 1949 [*1*], which Philipson unfortunately destroyed, but which it is possible to reproduce here because a photograph of it has been preserved. The presence of Kokoschka can even be felt behind the vigorous townscape *View from my studio window* 1954 [*2*], now in Glasgow University.

Since, later on, spatial balance was to become a key feature of Philipson's mature style, it is perhaps worth while devoting a little time to examining the Kokoschka influence more closely. The sense of balance-in-depth achieved by Charles Rennie Mackintosh, both in his secular interiors and in the interior of his Queen's Cross Church, Glasgow, was later to be echoed in a highly subjective manner by Philipson on canvas. It is therefore interesting to find that Kokoschka knew about Mackintosh, the painter writing of his studies at the Kunstgewerkschule in Vienna at the turn of the century that it was 'one of the most advanced teaching establishments in Europe, where one could not only find out, with the aid of the well-stocked library, what was being created in France, Holland, Belgium, Germany and England in the applied arts, but could also discuss in violent debate . . . the ideas of Ruskin, and his spiritual disciple, William Morris, further developed in Scotland by the 'Glasgow Boys' and the Mackintosh-Macdonalds.' (Peter Vergo *Art in Vienna from 1899-1918* 1975.)

What appealed to the young Philipson about Kokoschka was the combination of lyricism and expression-

[2] 5

ism achieved by the older man. It took account both of the scene and of the artist's experience of the scene. There was in Kokoschka's achievement a fascinating symbiosis of the objective and the subjective, making demands alike on intelligence, skill and feeling, all of which characteristics the younger man possessed. But they were not yet working harmoniously in his Edinburgh street scenes, for in spite of their vigour and the immediate appeal of their energy of construction and colour, the young Philipson was using the high palette and free rhythms of Kokoschka without finding the objective correlatives. For all Philipson's daring handling, the subjective element is too strong. It is difficult to believe, when one looks at *Edinburgh, Princes Street* (1955, Walker Art Gallery, Liverpool), that this heightened, ecstatic life ever existed in Edinburgh. This picture's success is thus as a Kokoschka-like view of the scene rather than as a Philipson view.

To discover and respond to the right master is in all the arts a necessary part of the artist's growing to be himself. There is no such thing as making a wholly fresh start, in art or in life-style, in spite of the contrary belief held by many young people who are themselves inevitable testimony to the flow and continuity of history. Some years ago a Marxist writer attacked Philipson, alleging that he was simply a mirror of his European masters, a pasticheur whose work showed a lack of a sense of social awareness. The attack showed as complete a misunderstanding of the proper function of painting as did the absurdly pathetic complaint of the elderly lady that a contemporary poet's work contained no obvious 'message'. 'Messages' of this sort should be left to the Post Office. An artist's style initially evolves out of imitation and emulation until, eventually, growing self-confidence enables his own integrity to take over.

Philipson's style shaped itself early in his career. He was not to be a portrait painter, however satisfying an example the *Self-portrait* 1947 [3] may be, nor a landscape painter like his friend Henderson Blyth and older contemporaries, Gillies and MacTaggart, in spite of the vision of the Edinburgh scenes. Philipson's preoccupation was to be with artistic statement, complete in itself: work that asked questions and posed answers in its own terms, as music does. To that degree, Philipson can be called an abstract painter, in that his concern has never been to produce the mere reiteration of open realism. In the limited sense that when he is painting a dog or a zebra he seeks for that moment to become, as it were, dog or zebra, his approach also has about it some of the essential qualities of expressionism.

Before he was able to put to the test his, by then, considerable youthful technique, the world was at war for the second time in the twentieth century. After a year's deferment from active service to enable him finish his Diploma, in 1940 he was conscripted into the King's Own Scottish Borderers, and later commissioned. He volunteered for service in India, where he was attached to the Royal Indian Army Service Corps. For two years he was able to travel widely in India, from the North-

West Frontier down to Bangalore. Then he entered the Burmese theatre of war. There, operating near the Kohima front, he had to take supplies forward to wherever they were needed. It was not, he has recorded, so much the fear of battle that frightened him, as the knowledge that the fragile loveliness around him was likely to be senselessly destroyed. He remembers, for instance, a particular time when he had charge of a post on the Dimapur-Manipur Road shortly before the battle for Kohima. Everywhere there was blossom; the hills were a flowering glory; and the Angami Nagas who cultivated the hillside terraces added to the colour, respendent in their gay clothes. 'Oh God!', he thought, 'I can't bear it that this is just going to be blasted'.

Before the blastings began, as the result of the flip of a Colonel's coin he found himself sent off into Assam. Fortunately, heads went back, tails stayed out, and Philipson was heads. The officer who got tails was shot in the back, the bullet coming out of his body at his jacket lapel. He recovered; but Philipson has often wondered how, surviving such an experience, he himself might have been affected.

From his experiences in the Japanese war in Burma, Philipson gained his hatred of aggression, large-scale or small. Yet the sheer size of the organised aggression of battle made him feel that a more brittle cruelty could be embodied in significant images once it had been subjected to the processes of design and the application of paint, so that it should not simply be decorative or merely illustrative. In this way, out of his own reaction

8 [4]

to personal experience, the terms of two of the themes that later occupied Philipson were born.

Back in Edinburgh, after undergoing teacher training, he joined the staff of Edinburgh College of Art. Henderson Blyth was then also newly back from the Forces and had joined the staff shortly before Philipson; they quickly became friends. For a term, Philipson looked after the College library until a teaching job could be organised for him. Philipson found that Blyth's bubbling enthusiasm and constant determination always to 'come up' with something new and better than anything he had done before, matched his own. To this day Philipson speaks with great admiration of both the man and his work.

One day Philipson was looking through a collection of sketches he had made of incidents in Naga villages. Some of these villagers had been Christianised by the Welsh, so the sound of Welsh hymns rose up from their valleys on Sunday mornings. Other Naga pursuits were not so gentle. Small in stature, the Nagas were greatly interested in cock-fighting, and would themselves jump about in their excitement like bantam cocks as they watched the sport. One of Philipson's corner-page sketches was of just such a cock-fight. Glancing through the sketches, Blyth lighted on this cock-fight at the foot of a painting now destroyed, and asked Philipson why he did not do a painting of 'that one', moving off without waiting for an answer. Philipson set to work, and a preliminary sketch has survived [4]. He soon discovered that he had hit upon his image of

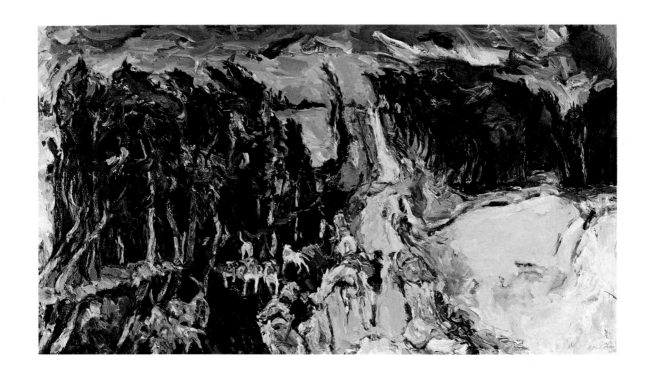

10 [6]

aggression reduced to manageable proportions of brittle cruelty. His first attempts were a series of arabesques, which he quickly decided were too decorative. He then began to variate upon his theme more deeply, seeking to catch moments of involvement, and handling the paint to enrich the experience, as a composer in similar circumstances would manipulate the texture of sound.

Preoccupation with this theme gradually led him away from his earlier interest in single-figure compositions and groups, in which he was concerned with problems of spacing and construction, as in his early series of still-lifes and hunt scenes. These show that he had not yet outgrown the influence of Kokoschka, although he had become a disciple whose organisation of paint surfaces and whose ability to register what T. Elder Dickson has called the 'sensations of both gesture and pictorial space' indicated maturing individuality. With the 'cock-fighting' theme, Philipson first found himself. In his cock-fighting variations he was applying the lesson he had learned as a student of keeping his eye both on the object and on the evolution of the painting. Anatomy and the physical posture of the birds mattered; but so did the build-up of the reacting paint. Here was already evident a restless tension that could not be content with the shelter of another man's shadow, however dexterous a performance such shelter safely ensured.

For Philipson, every fresh approach became a technical challenge, a battle with intractable materials to be shaped by technique, and won. A master of exact effect,

he deplores sloppy techniques, whether in the work of his students, or in that of other artists, however much the subject of fashionable admiration. With his cock-fighting series Philipson evolved his immediately recognisable personal style. Here was combined the reality of the scene itself with the validity of the feelings aroused in the artist by that scene. Here, working now in confident harmony, was the discipline imposed by the object and the freedom of the artist's response to it. Yet Philipson's expressionism is never arbitrary, as the frightening intensity of the best pictures in the cock-fighting series show.

Philipson thus set himself upon a course of image-making. Those that were to follow, whether kings, odalisques, bullfighters, or jesters, or with such creatures as cocks, horses and bulls, show a certain exotic quality, a fierce, overt sexuality. As often as not, too, they are used in pairs: cock against cock; king versus hunchback; horses confronted by fire; two naked humans, sexual yet not touching, or set against a third, fallen figure, or perhaps white figures against black. To all of these Philipson responds with vigorous and deep emotion. That, however, comes out of the impact of the finished product. To Philipson, what consciously counts is the technique.

It is perhaps sometimes difficult for those who are not themselves creative artists to understand to what degree the actual handling of material itself plays a vital part in shaping the finished symphony, poem, or canvas. 'In the beginning was the word' might be adopted

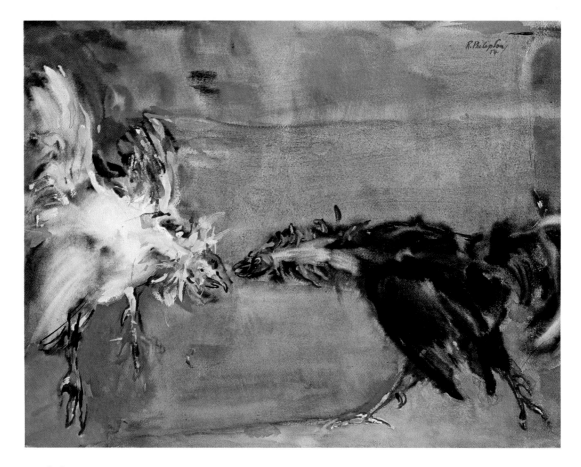

12 [7]

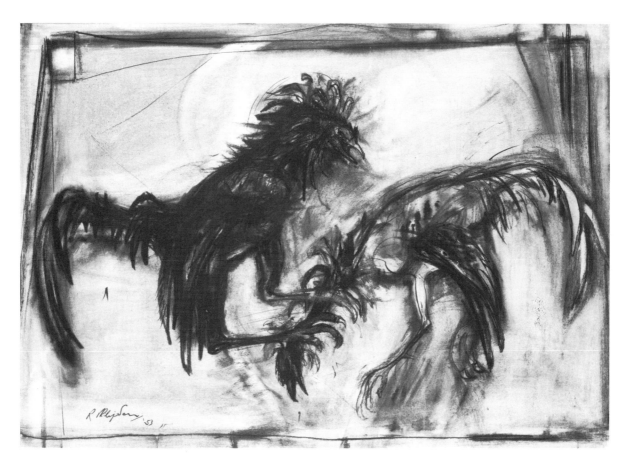

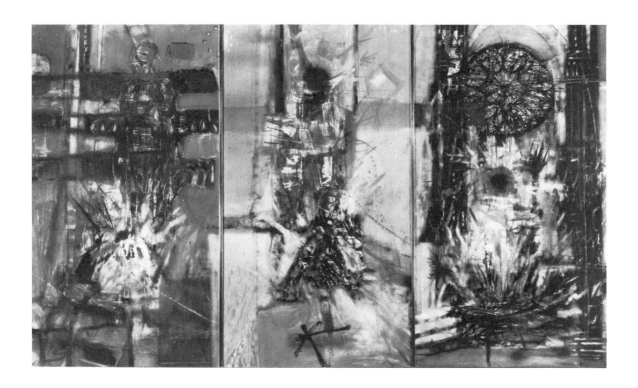

14 [9]

symbolically, substituting 'paint' for 'word', as this artist's motto; except, of course, that the existence of an assured technique is an essential prerequisite. 'You can't have a soul without a body,' the distinguished violin-teaching pupil of Sevčick, Camillo Ritter, proclaimed to his pupils, a fact obvious enough to artists if perhaps open to fanciful questioning by theologians.

The structural factors that interested Philipson in his cock-fighting series were the exact anatomical details of the individual birds at different stages of their behavioural relationship; and, of course, the variations in the constantly changing spatial relationships of claw, beak and feather, caught with split-second timing. The creative aspects of Philipson's most successful variations lie in the significance of the impacting of a rich, vigorously-layed texture so that the paint itself communicates, albeit in a totality of effect, as do the carefully-worked words of a poem or the thousands of individual notes in a symphony. As Philipson puts it, 'All the time the eye is watching the pull and push of a bit of red up in the top left of the canvas, a bit of brown at the bottom right.' If he is not to end up with simply a nice illustration or a pleasing arabesque, then the picture has to 'vibrate with a peculiar kind of movement'. The placing of colour is thus of critical balancing and tonal importance.

The earlier paintings in the cock-fighting series were predominantly red. Philipson then began to realise that this redness had something to do with the climate of reaction on the part of the observer – blood, 'seeing red'

anger, and, as psychologists tell us, the male sexual symbolism of the colour. Later variations varied the thickly built-up textures with flicks of grey, white, or blue; or, in the most recent examples, yellow. The effect is the heightened quality of disturbance, which goes far beyond the merely decorative or anecdotal.

While this development had been exercising Philipson's faculties, along with a more limited series of single-figure 'burnings', no doubt also subconsciously derived from that blasting of natural loveliness of which he had seen so much in Burma, other things had been happening in his life. In 1948, he was elected a member of the Society of Scottish Artists, once the refuge of the younger or more adventurous artists who, in pre-Philipson (and, indeed, pre-MacTaggart days) felt out of place in the then 'stuffier' Royal Scottish Academy. The following year he married Brenda Mark, herself a talented painter. She is celebrated in his painting *Brenda – spring portrait* 1951 [*10*].

Sometimes a marriage between two people practising the same art may founder when one of them draws ahead of the other in intrinsic achievement or public acclaim. It seems evident that in this exceptionally happy marriage of fun and hard work each admired the other's developing gifts. The fact that within a decade Robin Philipson was beginning to attract wide recognition was to his wife a constant source of pleasure. The marriage, however, was destined to end tragically, for after an operation for a brain tumour and but a brief illusion of recovery, Brenda Mark died in September

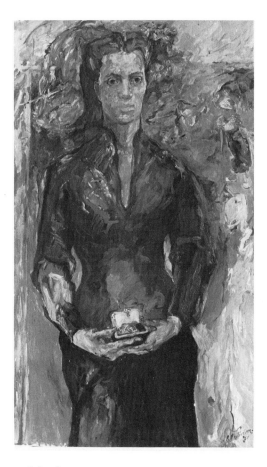

1960. The experience of watching the dying of the wife he loved, and one whose gifts as a painter he greatly admired, scarred Philipson deeply, although he did not allow it to affect the buoyant insouciance with which he has always faced the outside world.

In 1951 he won the Guthrie Award, a prize instituted by an admirer of Sir James Guthrie, a famous President of the Royal Scottish Academy, for the best work by a young painter in the annual exhibition, which entitled the holder to foreign travel. While not of great significance by European standards, coming at the moment it did it gave Philipson a sense of encouragement and confidence that was of considerable value to him.

Although he had already been included in a Scottish Arts Council touring exhibition, 'Eight Young Contemporary Painters', two years before, his first one-man exhibition was presented in the Scottish Gallery, Edinburgh, in 1954. This exhibition was largely devoted to his still-lifes and Edinburgh landscapes, which, though satisfyingly accomplished, as has been remarked, still showed the influence of Kokoschka. By 1958, when his second one-man show appeared in the same gallery, Philipson had been a member of the Royal Scottish Society of Painters in Water-colours for three years. In the year of the exhibition itself, he had been invited to produce the annual poster for the Edinburgh International Festival of Music and Drama. Its success is but one of many indications of his ability to turn his skills to other facets of his art than 'pure' painting.

The cock-fighting pictures also dominated Philip-

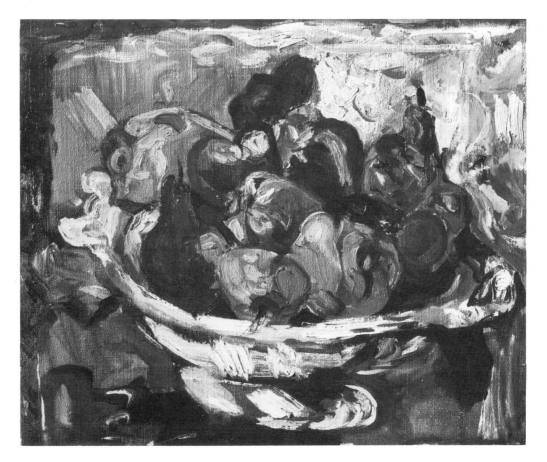

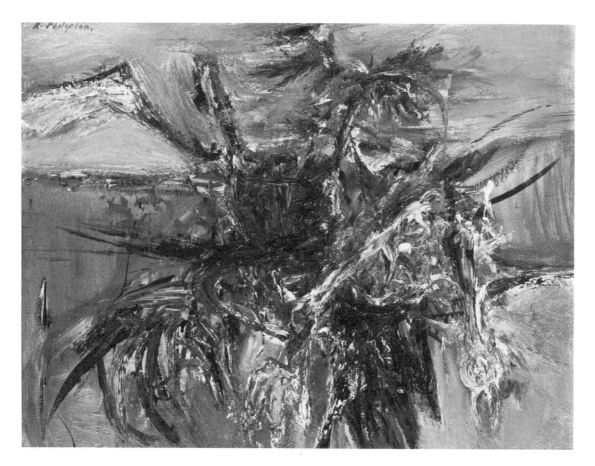

18 [*12*]

son's second one-man show at the Scottish Gallery in 1958, and his first London exhibition at the Roland, Browse and Delbanco Gallery in 1960. To those of us who experienced at first hand the effect these pictures made – the vibrations of natural savagery, their richly satisfying impact and self-contained statements in paint, their symbolism (albeit unacknowledged by the artist) of human primitiveness, it was clear that the Scottish school associated with the Royal Scottish Academy, with its traditional feeling for paint, its intense feeling for colour (and sometimes anti-colour), and its sense of mood, had gained a new and powerful adherent.

Emilio Coia has written of the 'theatricality' of these early paintings; and this, indeed, is one of their striking attributes. But, as Coia rightly observes, this apparent theatricality is an aspect of 'visual reality heightened and impassioned . . . a force properly integrated and never imposed'. In the early days of television in Scotland, the BBC presented their first television magazine of the arts, 'Counterpoint'. It was edited by George Bruce and myself, produced by Alan Rees, and I was the 'anchorman' and interviewer. The first edition, transmitted on 12 December 1958, featured an interview with the sculptor Beno Schotz while he was modelling the poet Hugh MacDiarmid. The failure at the last moment of two out of the three cameras forced us to devote the whole half-hour programme to what was meant to be a seven-minute item. The result was a finished head, the cast of which stands in the entrance hall of the BBC's Glasgow studios in Queen Margaret

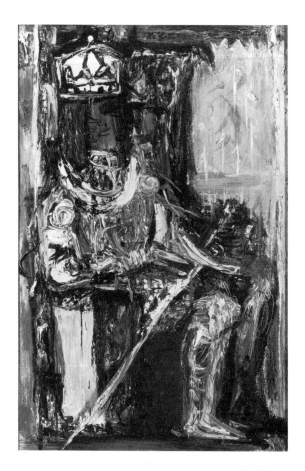

Drive. One of the items in a subsequent edition, an astonishing *tour de force*, was the creation by Philipson in front of the cameras of a charcoal variation of his cock-fighting theme, the skill in drawing mastered in student days enabling him to rely on structuring by way of compensation for the lack of colour and therefore of paint, a drawback endemic to early black-and-white television. It so happened that the next item was a discussion between Coia and myself on the art of the cartoonist, Coia drawing his interviewer, the result unseen by me, for the benefit of the viewers, while we talked. While the rest of the programme was proceeding, Coia turned his attention to his fellow contributors, presenting each of us with his cartoon at the end of the programme, Philipson's wittily inscribed 'A Cock-Robin Crow'.

Painters who develop themes rather than paint 'one-off' pieces eventually exhaust the possibilities of even the most promising choice. After the cock-fighting series, the next theme to present itself to Philipson was that of kings and queens. While the burnings theme, and the much more fully worked cock-fighting theme, arose out of Philipson's reaction to his own experience, albeit focused by selection and subjected to purely artistic processes, a royal subject seemed a strange choice for one so conspicuously non-authoritarian (though no believer in indiscipline, either for himself or others).

The king and queen series is probably the least successful of his themes and variations. Perhaps this is because his choice of it seems to have related almost solely to the outward opulence and grandeur associated with the trappings of royalty, which gave him the opportunity of creating patterns that were extremely rich. Indeed, he used the king theme to load thick, bright colour on to the canvas, tooling it with heavy brushes and neutrals until the texture was literally stirred. The effect this process produced had a jewel-like luminosity that Philipson was to make use of later to more rewarding purpose in his cathedral theme and variations. He himself now feels that the king pictures offer too little comment, and, for all their richness, rarely go much beyond the purely decorative. But they featured prominently in his 1961 exhibition in the Scottish Gallery, held the year after his appointment as Head of the School of Drawing and Painting at the Edinburgh College, and at his 1962 Roland, Browse and Delbanco show in London. This was also the year of his second marriage, to Caithness-born Thora Clyne, a very young member of his staff and herself a gifted painter, with a brother, Henry Clyne, head of Sculpture in Winchester College of Art.

In 1962, Philipson was elected a Royal Scottish Academician. In the following year, he spent three months at the University of Colorado, Boulder, USA, as visiting Professor of Advanced Oil Painting to a summer school, where his predecessors had included de Kooning and Kenzo Okada. This American visit gave him what he has called an 'inspirational shot in the arm'. It introduced him to new techniques and sub-

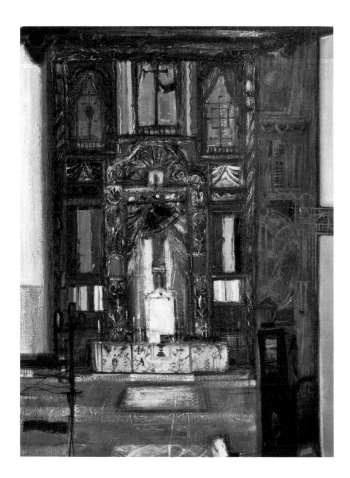

stances, including acrylic paints, with which he has been experimenting ever since, as well as the mixture of powdered colour and a resinous medium compatible with oil paint.

It also brought him into touch with Indian culture, the rough paint, laid on in slabs, to be seen in American Indian painting upon wood, in due course to become transmogrified in the 'altar' paintings, the genesis of which thus lay in this visit. The American Indian influence is to be seen more clearly in such a painting as *The screens, no. 3* [14], where, as George Bruce suggested, 'the centre feature of this vivid, dark-toned panelled work is a brown structure enclosing the wooden figure of a man whose trunk disappears into a weighty headpiece, with references in its obliques to Indian eagle symbolism. The supports of the structure hark back to totem poles.'

In 1965, the year also of a Leverhulme travelling scholarship, Philipson's work was featured at an exhibition mounted by the Scottish Gallery during the Edinburgh International Festival. For this, he turned to a new theme, much more relevant to his concern for the lot of humanity, and which, for want of a more accurate description, is usually called his 'First World War' theme.

Philipson was only two years old when that war ended. Of course a creative artist can write about or paint a murder without having actually committed one. In any case the psychological basis for his choice of theme was no doubt once again his own experiences a

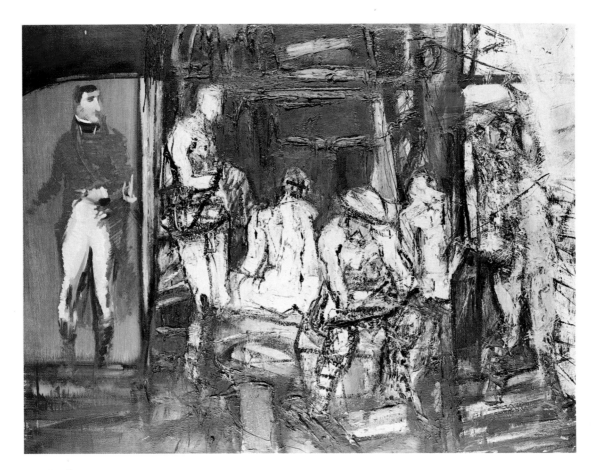

quarter-of-a-century later. The 1914 war had the 'advantage' over that of 1939-45 in that is brutality was more personalised. It has always been the 'brittle cruelty' of the personalised aspect of aggression that Philipson has found most suitable as material for his muse.

It so happened that about that time he began to develop this theme, the BBC was running a series based on events in the 1914-18 war. Philipson has put on record that this played no part whatever in his choice of theme. He even claims not to have watched the series. What crystalised his decision to adopt the First World War theme was, in fact, a visit to a cinema in Edinburgh's Tollcross area. When he arrived, the film was in progress. To the theme of a bland Christmas carol, soldiers were dragging a young man through snow, to put a black hood over his head, strap him to a post and shoot him. This set Philipson's nerve-edges on the raw, and firmed his determination to deal with human aggression; with war's insane destructiveness, its broad pathos and its individual tragedies. Once again he approached this theme out of his own transmuted experience, as always, in terms of paint. The works that resulted propound their own independent non-narrative validity.

One of the first, and most moving, is called *The other soldier* 1963-65. Strapped to a post awaiting execution, his outline rough and uncertain, the anonymity of his kind seems symbolised by the recognisably uniformed soldier not faced with the same fate, yet wearing an even larger hood. That 'story' interpretation of the picture does not, of course, define its implied statement and comment, since it is no more possible to do this with a Philipson picture than it is to state in literal terms what a poem is 'about'. The picture makes its impact in its own indescribable terms. Since art, however, exists as an attribute of human life, and not – as some *avant garde* artists appear to believe – the other way round, the pity, the horror and the indignation we are made to feel at 'man's inhumanity to man' can immediately be apprehended.

Stone the crows 1963-65 [*16*], ironically named after a slang expression of the times, depicts the rapid movement and confusion of certain phases of war, and is constructed as a build-up of film-strip cuttings, the borders ratchetted, as if forming part of the edge of a film clip. Perhaps the most beautiful and moving of all the war pictures is *Defenders of the realm* 1965 [*17*], a mandala, giving the same feeling of coming in, as it were, at different stages in time of the one vast prolonged experience.

This series was to prove one of his most extensive, and one which sometimes demanded large canvases. Thus it ranges from pictures of household size, to a large multi-panelled painting, in water colour, which now hangs on the walls of Edinburgh City Art Centre. (Incidentally, Philipson's only genuine mural, a 'one-off' work painted in 1966, is to be seen in Glasgow Airport.) In this wide-ranging series, the challenge of technical newness is met and overcome. Often, telling

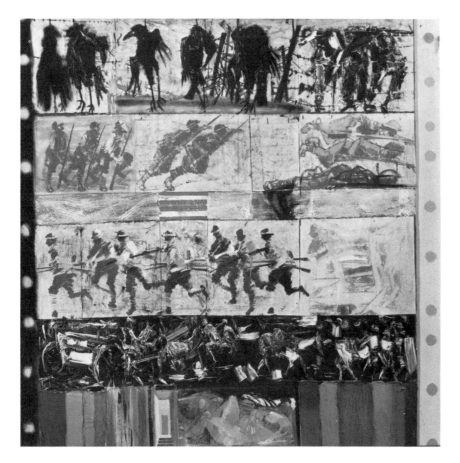

24 [*16*]

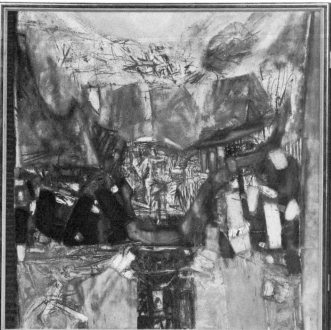
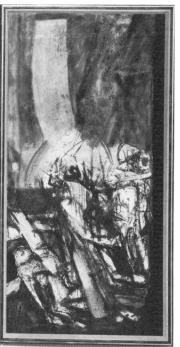

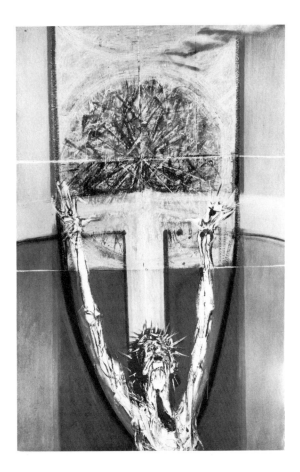

use is made of strong colour, sometimes brutally contrasted with grey, lustreless areas of bleakness, symbolising decay. Some of his effects, which are always relevant to the image he is seeking to convey, were achieved through the technique of rolling shaped pieces of Japanese water-colour paper into a bed of wet paint upon the canvas. Then, painting on the top of the paper, he secured a new effect, which suggested an additional dimension. Sometimes, the paintings in the war series are bordered with bands of colour, indicating the confining edge of all human experience.

With the war paintings went a series of crucifixions, two of which, dated 1966 [*18*] and 1969 [*19*], are illustrated. When the first in the series appeared at the Edinburgh Festival Exhibition of 1965, Douglas Hall perceptively wrote:

> The complex Crucifixions are back on the borderline between specific images and private abstractions. In the war pictures, he has faced the necessity of communicating his intentions more clearly, if still enigmatically, and this has resulted not only in greater clarity but in new formal imaginative inventions such as the unexpected, precisely painted, violently coloured stripes which can only be read as an abstract design (for feelings of claustrophobia, according to Philipson). The walls of stripes are brutally contrasted with the mud- and fear-grey human shapes that crouch beside them. There is no heroism in Philipson's war. In the pictures the only escape from fear is lust, and the

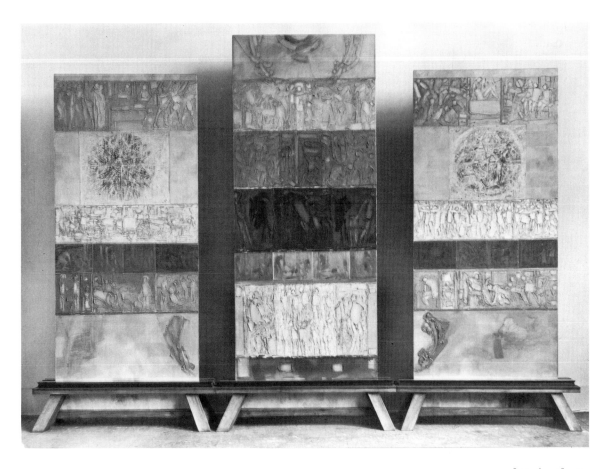

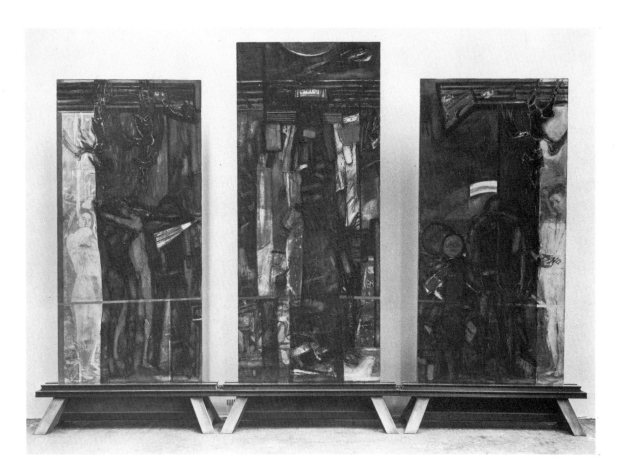

28 [*19, back*]

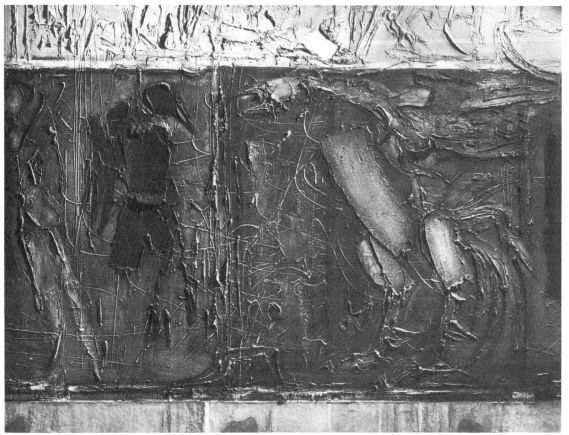

[*19, detail from front*] 29

used woman is a disturbing symbol . . . somehow hard and resisting among the slushiness, both temptress and victim, as the men who use her are themselves victims. There also appears . . . an illusory figure in white breeches, vaguely Napoleonic, who is perhaps the spirit of militarism . . .

In this connection it is perhaps worth setting down another illustration relating to the war series, which illustrates Philipson's lucid versatility. While Programme Controller of Border Television, I ran a series of television programmes, 'Kaleidoscope', dealing with the arts. It was financed by, and transmitted to, five companies of the Independent Television network, outside London. It occurred to me one day that the viewing public might be interested in the processes of definition and reduction that resulted in abstract painting. Philipson accepted the invitation to carry out the difficult task of defining and demonstrating the practice of abstraction in front of the camera.

He chose for his theme a detail from his large-scale painting, *On the edge*, in Edinburgh City Art Centre, a motif he called, loosely, *The soldier and the floosy* 1967 [20]. With astonishing agility, Philipson enunciated his theme in terms of realistic reportage, produced a variation that concentrated on the movement of the limbs of the two dancers, another that focused upon the movement of their clothes, yet another that combined the double abstraction, and a final one that showed the symbol for which he finally settled.

Philipson, however, seems never to have found 'pure'

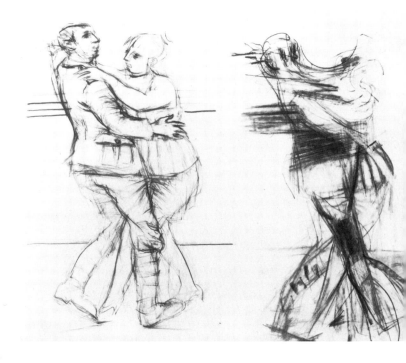

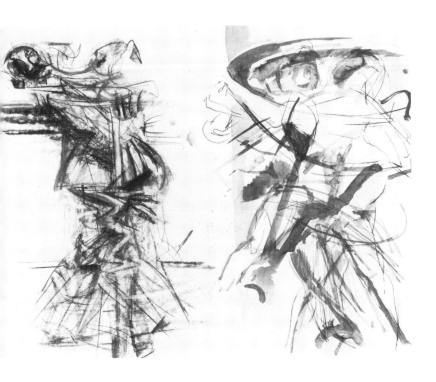

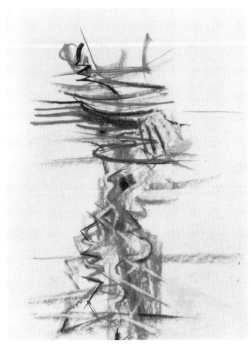

abstract painting totally satisfying. It is one thing to
take situations in which cocks confront each other, or
in which men and women are confronted with the
inference of a difference in the colour of their skin, or
where human beings of every colour are faced with the
enormity of war, dismember the factualities, and re-
assemble them fired, as it were, in the kiln of the artist's
imagination. It is quite another to take escapist flight
from the images upon which all life depends. For Philip-
son, there must be an implied narrative; the theme
itself; a story, the force of the development of which his
paintings so powerfully tell.

He himself has managed to achieve a kind of balance
between, on the one hand, the stridency of his cock-
fighting theme, or the setting up of conflicting opposites
in his 'white boy' and 'black girl' theme, combining and
enlarging the implications of all these tensions in his
First World War theme, and on the other the relaxation
into the abstract idea of splendour as a self-sustaining
entity in his 'kings' theme, and – with much more fruit-
ful result – the cathedral and altar themes of more recent
years, which sometimes, indeed, seem to create a kind
of suspended music.

Inevitably, when the cathedral theme first appeared,
the minds of some people went back to the famous
series of studies of part of the front elevation of Rouen
Cathedral, in differing lights, by Monet, now in Paris's
Jeu de Paume Gallery. Yet, while acknowledging
Monet's new use of colour, his skill in going inside, so
to say, a climate of roseate sunset at one extreme, or the

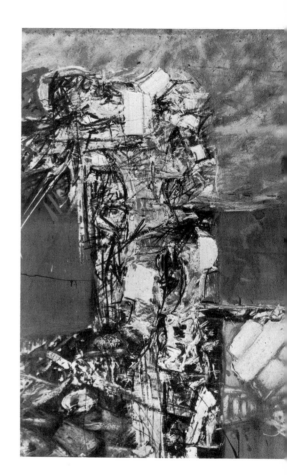

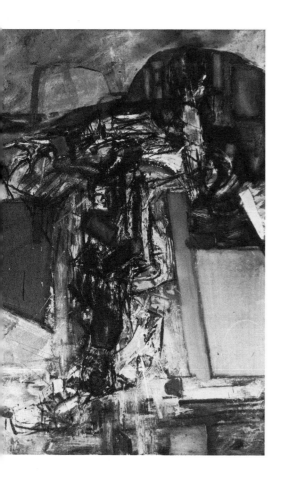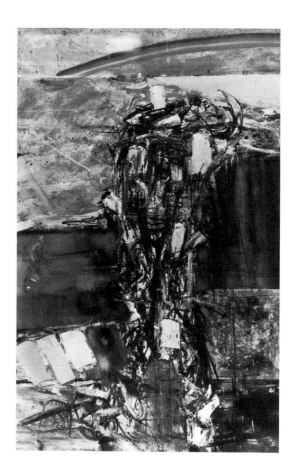

soft light of morning at the other, Philipson rightly disclaims any influence of these pictures on his own cathedral variations. Such a disclaimer is in no way surprising, for the Impressionistic approach of the great French artist tells us little about Monet's reaction to the building, beyond his originally expressed fascination with the interrelation of the texture of the stone and changing states of light. Much more than variations on a theme of light is involved in Philipson's cathedral sequences, a point made without any disrespect to Monet's masterpieces.

One other aspect of Philipson's scenes must be considered. Does he intend a religious interpretation to be possible? He disclaims any pietistic motives. Certainly, he has often been assumed to be a religious person in the sense this term is understood by conventional worshippers, and by people who perhaps want to read religious feeling into these works. Philipson simply thinks such people fortunate to be able to believe that they know what religious feeling is. It seems to him naive for anyone to assume that a painter can possess such a singular spiritual attitude, which no one else has and which, like a magician or like God himself, he can hand out from time to time in fragments of visual imagery.

At the risk of becoming caught in a thicket of semantics, I would suggest that in the sense in which religion may be defined broadly as an intense respect for life and its nobler values – the only definition that makes sense to me – then Philipson's sub-conscious attitude may be both secular and religious, as must be those of anyone manipulating successfully through technique the mysteries of human existence and of the imagination's creative processes.

What Philipson wholeheartedly denounces is dogma of any kind. Because dogma might possibly be attributed in a superficial fashion by some viewers to certain of the variations on his cathedral theme, he has been even more than usually articulate about the origins and aims of this sequence.

The cathedral that set it all off was Amiens, seen while on holiday. Why? Because, as Philipson puts it with a lofty disregard for architectural niceties, it possesses 'a very great beautiful thing rising with lots of stuff going in behind it', thus providing a variety of closely related in-depth situations that offer possibilities of pictorial correspondence. With the cathedral variations, as with virtually all his other series, Philipson's enjoyment of what might be called a depth co-relation is obvious. It is built in with the construction. For him, the edge-on, side-by-side relationship of literal happening can no more be a painting than the first theme upon which a musical movement is to be built can be regarded as itself the sonata.

What initially attracted him about the cathedral for a theme was its enigmatic majesty, its settled grandeur. At first he used the exterior, but moving in, found a further theme in the great circular window: the majestic rose, age-old symbol of the light of lights. The glow of light and colour, which the builders of Gothic

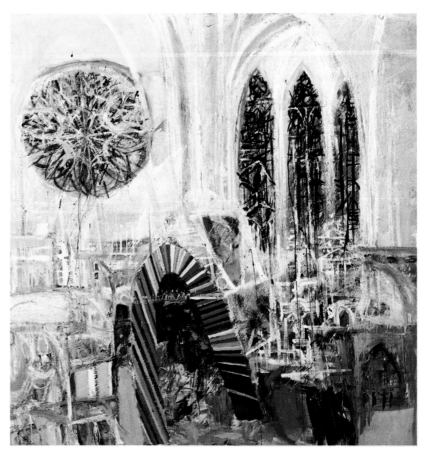

cathedrals meant such rose windows to reflect, overlaid with delicate tracery, moved medieval thinkers to devise theories of light. Seen as a solid, the rosewindow can appear to be another world, an effect which no doubt did not escape its medieval devisers. For Philipson, the challenge was to pull apart all the great building's ancient and indefinable associations in order to recreate in pictorial terms similar feelings of grandeur and space.

This, of course, is the way in which painting enjoys its particular triumph over the other arts. When visiting any great building, whether cathedral or castle (or, for that matter, a famous park or garden), one has no alternative but to keep walking about in order to see and appreciate its balance and proportions. A film has to be watched through before its full significance can be felt. Similarly, a poem must be read to the end, a symphony completely heard before it can be judged. Even a piece of sculpture has to be walked round before its mass can be appreciated. Only two-dimensional painting can offer the spontaneous immediate moment of unity, yet also permit, through repeated contemplation, planned rhythms unfolding on a bed of time.

In the case of his cathedrals, Philipson wanted to produce the sense of ascension, an aspiration to rise to a crescendo of colour. This he achieved, not by creating obvious rhythms but by the ease with which he could 'pull' the eye over the canvas in many directions, so that the viewer could experience a spontaneous intake of the whole of the picture. Thus, to seek to compare

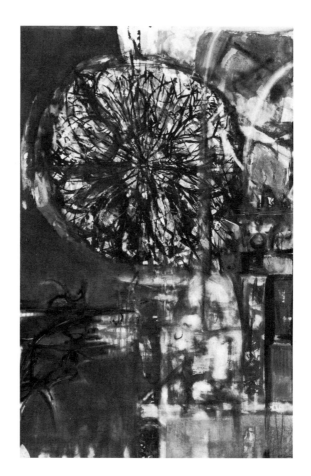

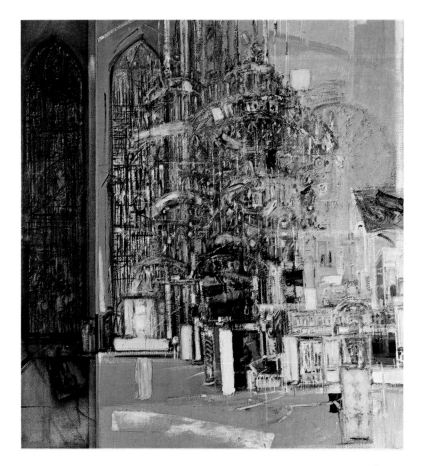

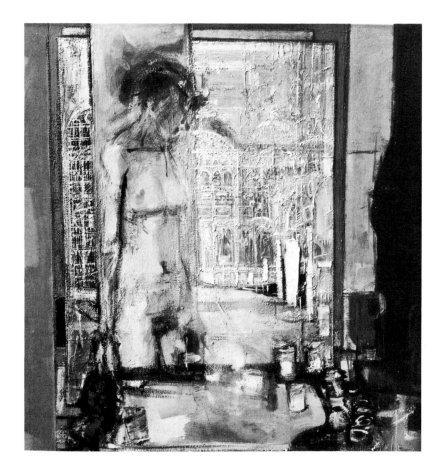

38 [*25*]

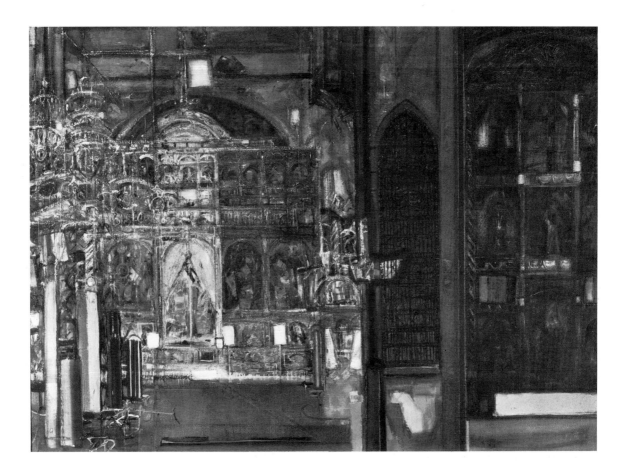

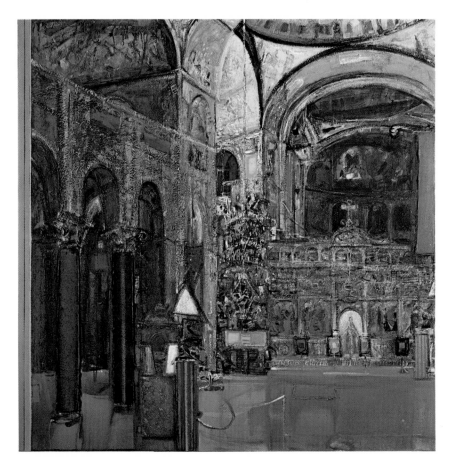

40 [27]

the Monet series, lovely and original and wholly characteristic of its creator as it is, with Philipson's much more extensive and elaborate sequences is as non-sensical as attempting to equate the scoring of a Mozart symphony with one by Mahler. Both are different varieties of masterpieces, and both must therefore be understood and enjoyed in the complete resolution of their own terms of reference. Consequently, no criticism of Mozart is implied by observing that Mahler's orchestration is altogether thicker in texture, and seeks to achieve different effects.

In like manner, Philipson's orchestration of his paint is altogether different from Monet's, and is directed towards a more encompassing experience; an experience, as it happens, given added significance by the evolving of his altar series, although, here, the basic impulse to be transmogrified into terms of paint came from a visit on a hot summer's day in 1963 to a little chapel at Santuario, near Santa Fe, USA. In this interior, Philipson was struck by the richness of the trappings, and the way in which it contrasted with what he has called 'the horrible paraphernalia of false belief', symbolised by the worn crutches laid in front of the altar to convince the simple-minded that some people had indeed miraculously recovered the power of walking. The sense of serenity illuminated by spacious chords of colour to be found in many of the cathedral pictures, takes on more human proportions in the altar series. The American visit of 1963 separates the European cathedral exteriors and interiors from those of the

interiors of the Mexican church. One is aware of the added strength that contact with the folk-idiom has provided, as well as of an added urgency of emotion. As George Bruce aptly put it in his preface to the catalogue for the Lamp of Lothian Collegiate Centre Exhibition of 1964: 'Through paint and shape, Philipson keeps us in touch with the raw material of the experience. He rejoices in the matière, but he does not see the expressiveness of the medium as an end in itself.'

Someone is supposed to have likened the sense of serenity that the Library in Charles Rennie Mackintosh's Glasgow School of Art creates to the slow movement of a late Beethoven quartet. While such fanciful comparisons have their limitations, and can easily give rise to misunderstandings, one sees what is meant by this particular comparison. The feeling of tightly-held sound suspended in space, which Philipson's first cathedral variations create, provides a similar experience. The free and vigorous lyricism of Kokoschka and the spatial balance of Mackintosh here come together, transmuted into a new experience, right and strange and entirely Philipson's own.

Cathedral and the contrast between the blackness and whiteness of human beings featured in Philipson's Edinburgh Exhibition of 1970, as well as in his London one-man show the following year. By the end of the sixties his pictures were much sought after, and he was becoming widely represented in public collections. His style had matured, although it had not changed in any

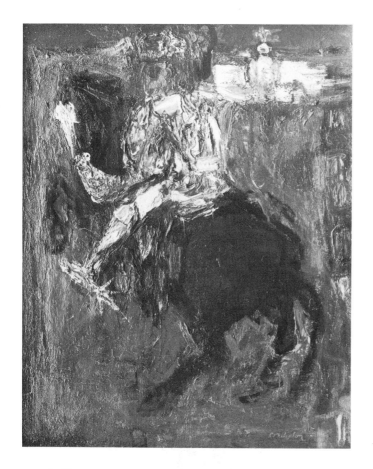

42 [28]

dramatic way since it had stamped itself on the art-loving public's mind with the cock-fighting series. Thoroughly and recognisably personal, many of the one-offs, so to say, which were more or less single explorations of a theme not further developed, were variously regarded by the artist himself as either 'hellish', or 'grand failures'. Such, he feels now, were the equestrian kings and queens that came at the end of the kings series. Yet they were not to be a wholly unprofitable diversion, for they led him to study the anatomy, postures and movements of the horse in detail: 'a majestic creature if ever there was one; until it's old, and sad and worn out. Then,' says Philipson, 'you begin to realise that the shape of a four-legged structure seems to sag much more unhappily than a person on two legs.' Philipson believes that it was probably some apprehension of this sort that prompted Stubbs to anatomise, and not merely the urge to know more. For Stubbs, he says, must have had 'a deep and powerful feeling for the horse'; a feeling that comes out in the licence he allowed himself when handling its shape.

There is also a link between those horses glimpsed through Gothic trappings in Philipson's equestrian king and queen pictures, and the recent zebra pictures. The changing shapes and rhythms and colour of zebras in motion or at rest have occupied his interest for some time, and still do.

As I have already suggested, he is not the kind of painter whose style has undergone sharp changes of manner, falling conveniently into 'periods', although there is one delightful series of watercolours, making the exception that proves the rule. What is clearly evident is his increasing mastery over difficult effects, and his apparently still developing ability to organise and energise paint in a manner satisfying to the viewer, discovering as he goes along newer and hitherto un-suspected statements of the theme he chooses to handle, whether old or new. Like most mature artists who work within disciplines of their own making, he makes richer use of his thematic material than he did in his earlier days. That the Philipson style is now unmistakable is proved by the fact that he is paid the compliment of imitation by students, and by younger painters of less originality than himself.

To what extent should an artist consciously strive after a personal style? Different artists would no doubt provide different answers, and it is the case that striving after a personal style at any price is too often the first consideration of many students.

Philipson has spent much of his time teaching. His pupils have included not only some of those among the younger painters who have already established their own individualities, but also the sensitive majority who must inevitably come to accept that they have nothing much of their own to say through paint, yet whose understanding of painterly techniques fits them for the essential role of spreading an understanding and appreciation of painting through schoolteaching. His views on style are therefore of special interest.

43

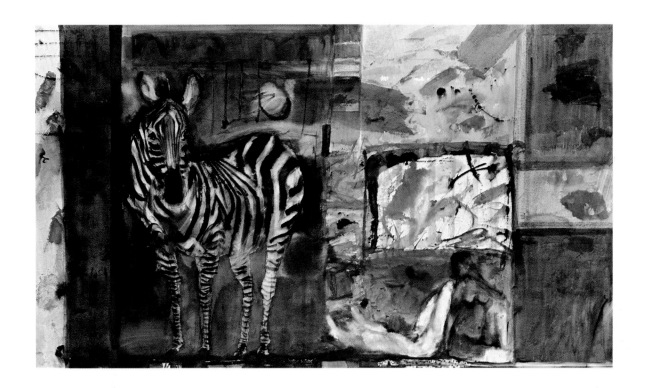

44 [*29*]

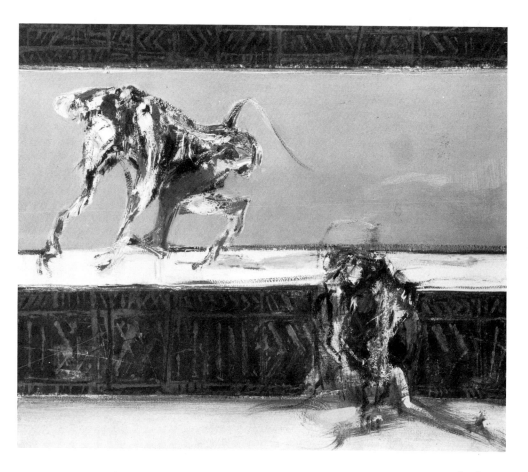

He says, characteristically, that he thinks style much more a matter of concern to the critic and amateur than to the painter. If by that one means the 'established' painter, then he is probably right. Style consciously sought after becomes mere mannerism; and mannerism usually disguises an absence of anything vital to say. Philipson's own way of expressing the mainly instinctive nature of the development of an artist's style is largely graphic, so permeated with that gentle modesty characteristic of his personality that his views are worth quoting extensively. They come from a privately-taped recording that I made with him in the summer of 1975, when preparing to write this monograph. The words are his own, my only editing being the tidying up of verbal loosenesses of expression acceptable to the ear, but less so where the written word is concerned: 'Viewers feel reassured when they think they can identify a painter's style by certain characteristics', declares Philipson. 'At times it is obviously the subject. At other times, it's something else. In the case of El Greco, it's the curious light and the elongation of his figures; with Rubens, it's his sumptuousness; with Titian, the gorgeous sense of underpainting; with Roualt, the thick coagulations of paint; and with Picasso, the utter mystery achieved through many and different approaches.' Philipson himself enjoys the sense of the luminous quality of a picture, the idea of a bed of paint being secure and evocative.

In order to try to get the heart of Philipson's creative processes, rather than simply let matters rest with his view on the characteristic qualities of his finished work, I indulged in further verbal probing. Imagine, I suggested, that he himself was a critic faced with the task of analysing the Philipson technique and presenting his findings to an audience. He began, and ended, with a family parable:

My mother was a dab hand at cooking. She had the facility of being able to create measurements through hands full of flour, a hand placed in an oven to gauge its temperature, and cupfuls of odds and ends. This absence of specific scientific measurements didn't seem to affect the delicious nature of the outcome. She had a curious sense of knowing without measurement. I think there is perhaps something of this same approach in the way I go after an image. I have got to get there, and I get there by sensing, by calculation with the anonymous measurements system.

If I pick up an immense weight of paint, it must be for one of these reasons: either because when applied, it is going to be interesting or special to look at by virtue of its blobbiness; or because it is not going to be easy to manage, and therefore I have to pull out of an insensitive, intractable situation the element of drawing required. I am thus deliberately avoiding the measuring or calculating systems invented by mankind for daily convenience. The problem is to get the message deep within oneself set down with the miserable means at one's disposal: paint, something with which to dilute it, the

brushes, the palette on the table, the canvas, some knives and one's fingers. So it's back to that old trick of my mother's: how you sense the mixture and the temperature of the oven.

Yes, I said: but what about the analysis of what comes out of the oven?

Firstly, there's the way the painting is done. In my case it's not alla prima; not just paint mixed up and put on canvas. A painting of mine therefore doesn't just move forward from morning through to night. I may have to meditate, for instance, on where I am going to put down white that will later be glazed over, so that I can get an immensely bright and luminous colour. I want all my paintings to have a curious luminosity. It may be a traditional thing, but it does allow one to have colours of great resonance. Secondly, in my case, the images created are not hard-edge, and so don't fall into the general vocabulary of much contemporary art, and I rarely use photographs, or photo-litho processes.

I frequently calculate certain vagaries at the edges of my images, so that there is an ambiguity as to the real nature of the silhouette or outward perimeter, in relation to the bed on which it is seen. Occasionally, this edge may be vague; or it may be so contained within the image that, against the background, it can be rather difficult to see. This is drawing made by paint, though not necessarily flat paint. I attach great importance to the way I draw with the braded and often awkward brush.

Thirdly, there is the rough, coruscated surface thus created. This, for me, is rather essential, tied up with a definite intention to make the substance itself aggressive: like a difficult-to-handle pulling-against thing; perhaps, for instance, like the blind pulling of a restive horse, and also because the substance inherently contains opportunities of which at the moment of application I may not yet be fully aware. In other words, I'm not completely master of the situation in advance; not in total control of what may be going to happen.

I would hope that out of this involvement there will emerge a special kind of drawing. Indeed, I think perhaps there is an oddness about the drawing I use. It is not a calculated or measured drawing in the geometric sense, but more a matter of necessity resulting from all the processes which I have been trying to describe. To sum up then: I'm not a hard-edge man. I'm not a flat pattern maker. I enjoy the value of the substance of paint, either as an aggressive thing against which I have to fight, or as a thing which occasionally – very occasionally – comes under command spontaneously in a totally new and unexpected way. It goes without saying that I enjoy rich colour.

If one had had the privilege of interviewing, let us say, Beethoven, his answers, translated into terms of sound, might not have been so very different. The composer, of course, thinks in terms of what notes can be made to do; the poet, with the potentiality of words.

48 [*31*]

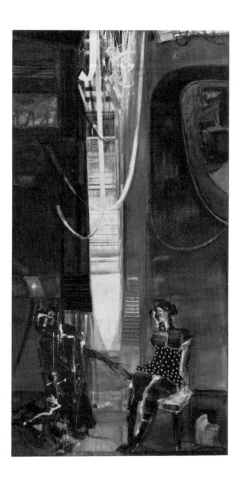

Those who do not possess what romantic people sometimes call 'inspiration', which is certainly an instinctive quality not attainable through mere mastery of technique, can produce only manipulated work, quickly forgotten. Yet the artist must concern himself primarily with the artefact, the shaping of the actual material he uses, without the command of which 'inspiration' is useless.

Asked what the power of the sea was, Joan Eardley once remarked: 'Very often, it's just the power of grey.' Of course, when we look at one of her late sea-studies, we know that it is very much more: 'the power of grey', with perhaps a flash of blue and a flash of white across the top of a wave, may be the technical means contrived by the artist as the response to the instinctive urge that goes beyond calculable technique.

In Philipson's case, when he deals with a cathedral, an altar, or two human figures, he knows very well that in the matter of literal seeing, mankind is, so to say, ahead of him. Since men and women have also seen these things in real life, an illustrated re-rendering would simply be boring. The challenge to Philipson is always to rephrase, to illuminate the realistic object so that the viewer may experience, as he himself has put it, 'a new moment of dreaming about its reasons for being there'. That moment of dreaming is achieved by the manipulation of image and colour and texture, and if done well, it can also induce the viewer to wonder *how* it was done.

How, not *why* in the first instance, is Philipson's

hoped-for order of responsive priorities. No artist is ever able to tell all that is knowable about himself, let alone about what other people are trying to do, or even what he himself would like to do. The conflicts and the tensions between man and man, man and woman, man and his buildings, and man and God, are ultimately unresolvable. What Philipson seems to strive to do is to fasten upon the divisive elements, isolate and clarify them, and so make the possibilities of resolution just a little nearer. Art can do no more.

For a painter as dependent on themes with potentialities for extensive development as Philipson, there would always seem to lurk the nightmarish possibility that he might run out of themes; precisely the situation that, when it happens to Francis Bacon, makes him decide to paint himself.

Philipson says that in fact his themes seek him out; he does not have to go hunting for them. The idea comes, so you face the canvas. That makes it seem relatively simple; but, as anyone who has ever faced a blank sheet of paper or the empty staves on a piece of music manuscript knows, the basic idea and the creative intention must come together in what is at first an artificial situation. Dependent on what happens thereafter, through the prompts that he gets from 'goodness knows where', the processes grow into a new integrated unity: the scratches organise themselves on paper or canvas. As William Buchanan pointed out in his preface to Philipson's touring Scottish Arts Council Exhibition 'Cockfight Rosewindow' (1970), there is something essentially fundamental about the Philipson approach. Buchanan quotes Desmond Morris's *The Naked Ape*, in which the zoologist formulates rules that, he claims, apply to painting, music, writing and other activities. These are: '1. you shall investigate the unfamiliar until it has become familiar: 2. you shall impose rhythmic repetition on the familiar: 3. you shall vary this repetition in as many ways as possible: 4. you shall select the most satisfying of these variations and develop these at the expense of the others: 5. you shall combine and recombine the variations one with another: 6. and you shall do all this for its own sake, as an end in itself.' As Buchanan comments: 'By these rules Robin Philipson must be the archetypal artist.'

Philipson feels happiest when the means nudge a little bit ahead of the subject: 'You know you want to do something', he says. 'You get a feeling coming up your back you want to paint in this way or that in this next span of time, be it a year or a decade.' With his interest in new materials, in the case of one of his themes, the means was a desire to produce a 'powdery odd look, because vinyl tolerates certain properties'; with another, it had to do with the laid-down structure of big slabs of paint, difficult to handle technically and, once down, providing a foundation conditioning everything else that could be done.

Adapting and extending familiar techniques already referred to, for instance, to secure a luminous, ghostly effect, he lays down a bed of white paint. While it is still wet, he then paints into it with monochrome colour.

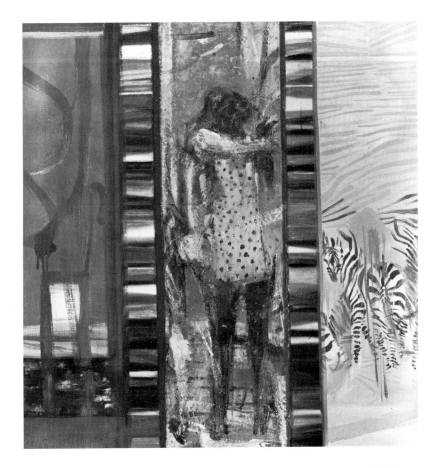

Again while still wet, he gently lays down a sheet of Japanese print paper until it joins with the paint. The image comes through the paper as a faint, ghostly echo. Even if he then glazes the whole surface with very rich colour, the image underneath remains secure. Other variations of this technique have involved the deliberate crinkling of the laid-on paper.

When in America, he found that his students were interested in painting the shapes of pelts. Philipson then decided to paint on leather, using the hot-point of the leather-worker and perhaps adding gold leaf. While he finds leather an interesting surface to paint on, he regards it as only suitable for small-scale work. His use of old photographs, as in the Christmas card that includes a picture of the artist and his twin sister as very young children, placed there to give a point of contrast and to produce a new orientation, he also regards as of minor value. Whatever technique he uses, always his concern is to achieve what he calls 'the two-dimensional pull'.

Louis MacNeice has propounded the theory that the writing of poetry is to some extent a therapeutic process; so, too, with painting. Philipson would agree. Once his theme is embarked upon in the face of technical challenge, it becomes identified increasingly with the extraordinary world of the imagination, until, by exploring it fully, he is brought back to a position of equilibrium and calm. That is the moment when he decides either to test the endurance of this or that colour by pushing things a bit further, or simply to wait for another theme to present a fresh challenge of aggressiveness, to set him once again on the raw nerve-edge of discovery.

There is a striking similarity between this aspect of the approaches to creativity of MacNeice and Philipson with the approach, recently set out with easy clarity, by the designer and painter Bernat Klein:

When one sees a bowl of parrot tulips and gets excited about them, one may see them first, I suppose, more or less as anyone else would see them; but the moment one starts painting them, something happens and one begins to simplify the shape of each flower, to relate the shapes and the positions of a number of flowers to each other, to relate the long, thin stalks to one another and to the vase; one imagines and, if possible, arranges it all against a special, pleasing, related or contrasting background and all this happens without much conscious thought – almost automatically. In addition, probably a number of other things also happen while the painting proceeds; a texture may suggest itself as a result of the strokes of the brush or the palette knife; this texture is identified, fixed and elaborated on; developed and made into one of the rhythms of the painting; a new colour appears as a result of many mixings and juxtapositions – themselves the result of a certain amount of consideration – and one uses this colour, which in some way is quite new, as the underlying theme for the whole painting, to make parts of the

painting relate and integrate. . . . Somehow between the moment one first saw them and the moment one applied the first dab of paint to the canvas and increasingly as one went on, the actual tulips have changed into something different; they have become an exciting, new arrangement of colours, shapes and textures which, on the face of it, bear only a slight resemblance to the tulips one might appear to be painting . . . one is no longer painting just tulips but certain other ideas which the tulips have caused to come to the surface of the mind – especially certain colours and textures which they suggest but which they do not actually contain and to which they do not strictly correspond. In fact, objectively speaking, one is not painting tulips at all; one is capturing a state of mind – brought about by seeing some tulips. One is sending out a tulip-based message. . . . (*Design Matters*, London 1976)

Klein, of course, being primarily a designer and a markedly lyrical one at that, does not require Philipson's sense of narrative flow to enable him create. With Philipson, what is being sent out is a human, predicament-based message.

Some years ago, I asked Philipson how long he felt he could occupy himself with a theme before he felt that he had explored all the permutations and combinations of its possibilities. He reminded me that the danger came when the viewer, perhaps looking insufficiently closely, felt that a theme was becoming overplayed. From the point of view of the painter, it is sometimes the case that, when a theme seemed virtually on the verge of exhaustion, he was really on the threshold of making a new statement about it. As Philipson has moved from theme to theme, he has gained confidence in going forward even when, seen in chronological sequence, there might seem little difference to the casual eye. But when an early variation is compared with a late or middle variation, the difference becomes obvious. This is well illustrated by Philipson's late return to the cock-fighting theme, even as recently as in his 1975 London Exhibition, where his *Cock crowing* [*33*], shows a subtlety of energy, gained through contrasting colour, far in advance of his early variants.

Critical reaction to Philipson's work, though enthusiastic in Scotland, has been slower to follow in other quarters. There is nothing surprising about this. No country in Europe is more complacently self-centred than England. Such bruiting abroad of the Scottish arts as the mis-named British Council is supposed to have achieved foundered in the uninterested morass of English parochialism, a point well illustrated by the fact that a so-called series of British Council literary pamphlets, though including countless minor English writers, failed for more than twenty years to include the Scot, Hugh MacDiarmid, a European figure by any standards.

Critical reaction to Philipson has thus come comparatively late in his career. There were those who, in

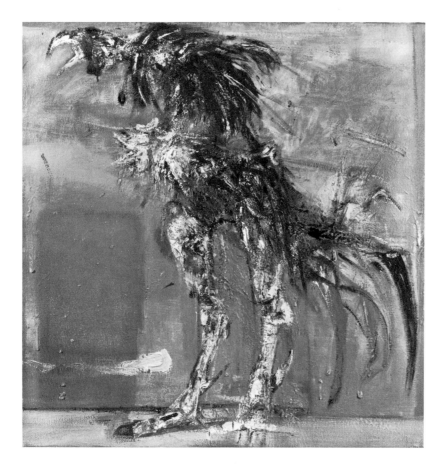

54 [*33*]

newspaper reviews during the fifties and sixties, complained that he sometimes fell back upon rhetoric. No painter as prolific could wholly avoid these charges. But with the paintings of the seventies, the rhetoric has been swept aside.

One of the most preceptive public discussions on Philipson's work took place as long ago as 1960, when on 30 October the BBC London programme 'The Critics' took his first London exhibition as one of their themes. Eric Newton, then Art Critic of *The Sunday Times*, said:

> We're concerned with Robin Philipson as a painter. First question: Is he a good painter? Second question: If so, what kind of a good painter?
>
> I think he is quite exceptionally gifted as a *painter*, which is not quite the same as saying he is a good artist. But I would not have asked you to discuss him if I had not considered him a good *artist* as well. The distinction is fairly obvious. But my point is that he is the kind of good artist who would be helpless if he were not something of a magician in the handling of paint.
>
> Can we define him? He has obsessions. Two of them are quite evident in the show. One is Gothic cathedrals; the strength, the complexity of their outsides, the glow and the mystery of their interiors. The other is cocks fighting; the vicious anger of their beaks and talons; the jab and the flutter and the fuss of their feathers. Anyone who can paint both these subjects and capture their overtones – the solemnity of the cathedral, the hysterics of the cockfight – is a real artist. But in order to capture overtones, he has to be an exceptional painter, a man who handles the stuff as as easily and as confidently as we hope to handle words.

Under the chairmanship of Lionel Hale, they then went on to handle their confident words about Philipson, Eric Keown saying: 'I like him because although he's a modern painter, he does give you straightaway his terms of reference ... I find him exciting for his clean, beautiful colours, both in oil and in watercolour, and for the irrestible energy he can get into a canvas. I can't remember any canvas which is as explosive as *Cocks Fighting*: two cocks tearing each other to pieces so powerfully and so rapidly that ... you think the whole thing is going to explode in your face.'

Paul Dehn then proceeded to suggest that Philip'son's province was too limited; that a great artist is one who 'takes many available themes, indeed all life, as his province'.

Eric Newton summed up by observing that the days when a patron knocked at the door of an artist and said 'I want a Crucifixion', or 'I want a Last Judgement' were gone. 'This', Newton added, 'leaves the artist to find his own obsessions; and once he's found an obsession, he finds also that he has to paint picture after picture in order to squeeze the last drop of juice out of it. . . . It will be interesting to see where Philipson goes next.'

As we know, Philipson has developed into an artist able to take 'life, as his province'. In his own comment on the huge triptych *Gethsemane*, with its pendant details beneath, which hangs in Argyle House, Edinburgh, Philipson remarks: 'These smaller panels contain a more fixed reality, where the scale of the figures registers with greater precision; and they hint at the prolonged records of man's agony and of his inhumanity. The important panels for me are those containing the fleeing figure and the broken, kneeling figure.' Unfortunately, Eric Newton did not live long enough to get the answer to his rhetorical radio question.

But more recent critics have saluted the mature achievement. Writing of the 'Cockfight Rosewindow' Exhibition referred to earlier, the Art Critic of the *Daily Telegraph*, F. W. Fenton, saw a stable unity between the two themes. He remarked:

> Colour, which though entirely Scottish, is generally more sober than resplendent, may have something to do with it, but the conflict and pathos which animates the cockfight theme flow over into the rosewindow pictures, where tension is set up between the round windows and the architectural uprights. Peace is there, but it is fragile in an era still plagued by conflict.

Fenton's tribute to the development of both themes is not without interest:

> As they become more aggressive, the maddened birds become also more tattered and weary. In one oil they are little more than skeletal near-white forms, and in another ragged, black, nearly exhausted birds. In *Cockfight, Study* of 1966, two birds face each other across a panel of a colour so gentle it presages the rosewindow pictures.

The rosewindow theme, also defined in watercolour, is given a much smoother treatment. . . . Two paintings of Amiens Cathedral are of the exterior, but it is with interiors that Philipson is at his finest. In these he superbly expresses the serene spirituality of soaring Gothic architecture dominated by the glinting circular symbol of the window. Soft gold, creamy white and deep shadows flood every scene. Spirituality is a little more elusive when Philipson seeks precise definitions, but each picture has a monumental nobility that stems from the Old Masters.

Writing of the same exhibition when it was mounted at Dunfermline a few weeks earlier, the art critic of *The Scotsman*, Edward Gage, somewhat surprisingly placed Philipson in the 'romantic tradition of painting laid down and forever typified in the work of Eugene Delacroix', a statement I find somewhat baffling, except in the unimportant matter of rhetorical gesture of theme: with Delacroix, the romantic be-all; with Philipson only the beginning of a voyage of exploration, or perhaps the occasional lapse of an off-day. However, Gage went on: 'He delights in sensuous pigment and coruscations of colour, his paintings often vibrate with intense energy and movement, his feelings are evident in every brushstroke, his imagery is heavily symbolic

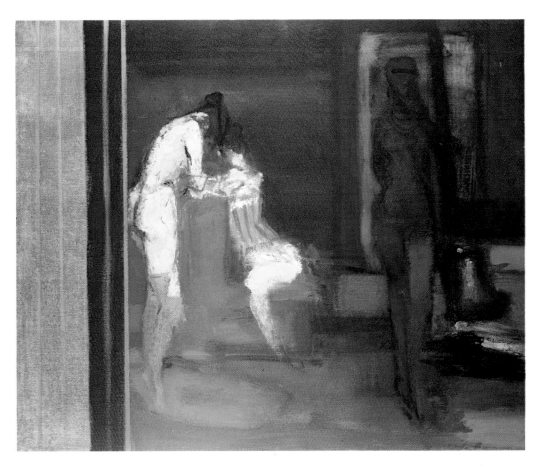

and his themes are often exotic, or literary, or dialectic, or even grand in concept to the point of reflecting the whole of the human predicament. But he is very much a man of his own time and northerly latitude . . .'–no bad summing up of Philipson's qualities in precise form. Other Scottish reviews have echoed less tersely the views so admirably expressed by Gage.

Philipson protests from time to time about the increasing amount of his own energy that has to be devoted to administrative or civic duties. He chafes at the growth of a bureaucracy, which results in even his students having to make an appointment to see him. He shares with Gustav Mahler the irksomeness of being primarily a Saturday and Sunday creator. Yet just as Mahler probably needed the stimulus of conducting to satisfy his psyche, so perhaps does Philipson benefit from the practical and exacting demands of teaching.

But he has also taken on civic duties that someone with a less active sense of public responsibility might easily have avoided. In 1965 he became a member of the advisory body to the Secretary of State on buildings and the environment, the Royal Fine Art Commission. In 1967 he was elected a member of the Edinburgh Festival Society, subsequently from 1969, sitting on the Council. In 1971 he became a member of the Scottish Advisory Committee of the British Council, and in 1975, after the reorganisation of Local Government in Scotland, a member of the Advisory Committee to Lothian Region Council.

The artist must, by nature, be a solitary person. As Burns put it:

> The Muse nae poet ever fand her
> Till be himsel' he learned tae wander.

The value of Philipson's presence on these public committees is the ready application of a keen and sensitive mind to the everyday problems, the solution of which is their responsibility. The value of the varied associations committees such as these provide may perhaps by gauged by the advice he gives to the student who is seeking guidance on whether or not to embark upon an artist's career: 'Don't underestimate the incredible, almost horrible, loneliness.'

In his role as teacher, Philipson takes a liberal and tolerant view of those who feel that the old ways, the traditional media, are not for them. He is, for instance, sympathetically interested in whatever may be the ultimate development of Land Art: the practice, which many young artists have been pursuing for two decades or so, of looking at man's bric-à-brac that may be lying about a city, in order to reappraise it as part of the human habitat. He does not condemn the student who feels that the canvas and what might be done with it are not for him, or the youngster who eschews painting to explore what happens when a man's imagination becomes three-dimensional. He is willing to admit the possibility that Land Art, or something like it– legitimate, in theory, because it is fundamental to the basic experience of awareness of being alive–may even throw up something of permanence.

But he has little patience with fashionable charlatanry or gimmickry for its own sake, an impatience, I may say, that I fully share. Some years ago, the Scottish Arts Council presented a number of so-called street exhibitions, one of which consisted of a shop window in which was an old car, painted white. Several white-coated figures from time to time struck it with hammers. During a chance meeting in Edinburgh's George Street, I vented to Philipson my irritation that what seemed to me, however interesting to some, merely childish and boring should be presented to the public for serious consideration as a form of art, and paid for out of public money. Philipson conceded that the people who stage such events must be willing, and able, to define to the public the standpoint from which they are operating. Yet who could say that amidst the loud noises of street gimmickry, some watchful, creative person might not find the germ of an idea, which he could develop and give to it the form of artistic permanence? Even so, the fact that we are 'ankle deep, or more than ankle deep, in impermanent and shoddy artistic endeavour', should not, he feels, allow anyone to lose sight of 'the special opportunities that are even more exciting by using means that are basically traditional'. Those who seek to bemuse the public by gimmickry, the kind of artistic equivalent of 'streaking', 'cannot ultimately make much impression, because human nature, the human spirit, is seeking for a permanence which does not hang by the thread of sensationalism'.

Sensationalism – the attempt by the artist to shock by 'sexual naughtiness', as Philipson puts it, or aggressive provocation of other sorts directed at engaging the dubious attentions of the journalist – seems to him of as little ultimate importance as hostile, uncomprehending criticism, which can do more than hurt the shell of the artist, but however wounding the intent, cannot ultimately destroy him.

One sees his point. Apart from any other consideration, there is almost nothing left that can possibly provide a visual shock to any reasonably sophisticated viewer in the final quarter of the twentieth century. And in the end, the meaningful and calculated standards of those who seek to make the quiet statement – however much internal turbulence may have preceded their setting down of it – related to human values honoured by successive generations, seem most likely to result in paintings of lasting value.

Philipson does not entirely condemn Pop Art, any more than he condemns daily journalism, to which he rightly likens it. His advice to the public, whether looking at his own painting or anyone else's, is to seek out what he, the viewer, likes himself, then study it intensely, asking himself (or herself) why he likes it. From the stepping-stones that will thus emerge out of the current of initial bewilderment, it may perhaps be possible to discern another, and another waiting there ahead.

Yet he does not underestimate the daunting nature of the problem which faces the viewer, subjected to so

60 [35]

much contrived and meretricious sensationalism. Equally, he deplores the attempt to search for more direct literal images in his pictures, seeking meaning from them when the real meaning is in the balance, texture and the construction of the whole. One thinks of Goethe's famous remark anent a piece by Bach, which always made the poet think of a great crowd of finely-dressed men and women moving up and down a staircase. But Goethe was wise enough to add that he did not for one moment believe Bach to have had any such notion in his mind.

Philipson has not, for obvious reasons, indulged much in public criticism of the work of his contemporaries. That he has a considerable ability to analyse a picture in such a way as to make its appreciation by the viewer much more vivid has been demonstrated by some of his comments to John Arnott, in BBC Scotland's radio programme, 'The Arts in Scotland'. Speaking of sea-pictures by Joan Eardley and by the elder M'Taggart – 'Grandfather' M'Taggart – Philipson said:

> If I were to choose a special favourite, I think it might be *Lobster fishers, Machrihanish Bay*, because for me it is a very beautifully composed painting. In fact, I feel that the cool, quiet painting of the sea is almost a miracle of no paint! We have the introduction of figures, men in the boat pulling hard against the tide. The figures, the water and the boat seem to be subservient to the gaiety, almost the frivolity of movement in the water itself.

M'Taggart was a master at cutting a horizontal line by using vertical masses. This, I think, is a very splendid example of the balance of the left-to-right movement, which he seems to be able to create in so consumate a way. Having watched the turn of day and the mood of the year and confronted the sea, M'Taggart became able to catch the essence of the water's edge. Gradually, as he developed, this preoccupation gave place to a deeper awareness of the power, the moodiness of the sea. In his magnificent painting *The storm*, one begins to find a conflagration between land and water. The water seems to be forcing its way in from the right-hand side of the picture, with its dull blues and angry speckles of white against a fiercely dark sky. They are pushing over towards the land and a more illuminated sky, where he has placed little groups of people, who obviously know that they are incapable of holding back its force. The land and the water seem to breach the angry mood of storm. The natural description is uncannily wrought, the figures integrated with the land and the water aggressively pushing against it, the whole thing held by a single line of white foam echoed by a white cloud. . . .

In another, quite small painting, M'Taggart addresses himself to a single wave; a picture with almost oriental elegance and massive simplicity of design, where a cool wave sweeps from left to right across the canvas, and a small irritating

smudge of debris trickles in from the right to the left to give a quiet moment of rhythm. That, for me, is quite superb.

Next, we have a painting, *Summer sea*, by Joan Eardley. She, too, was a superb painter of the sea. She stood before it on the sands at Catterline Bay, with her paints in an old pram, and her easel and canvas anchored down, pretty much as M'Taggart did, with a heavy stone; and she tried to create with a flourish, a brave, well-informed brush, the physical movement of the water itself, its crescendos, its subservience to the wind. In this painting we find a lowering dark foreground and a soft, limpid blue-grey sky in horizontal force, containing the explosive matter of wave and weight of water.

Even when confronted with a portrait by an artist as wholly different from himself in approach as Sir Gerald Kelly, Philipson can evoke the quality of the painting within its own terms of reference.

Take this portrait of Jane, the wife of Sir Gerald Kelly, painted probably in the early or mid-twenties. It looks very much as if she had said to him: 'Why don't you paint me looking like this?', and he has chosen a long, rectangular canvas and placed the figure centrally. She is wearing a beautiful black coat, in the manner of the day. The painting is a very simple harmony in tone, and the black coat reveals the strict design of the time. She is looking at us over her left shoulder and a mon-strous collar, which is capped by a lovely hat with a feather. These open, shell-like, to reveal with brilliant luminosity the shadow-eyed look of this rather beautiful woman. Sir Gerald's decisions are elegant in the way he has illuminated the white gloves, giving a sparkle and freshness matched by the drawing of the shoes. Very much a portrait of the period, it is undoubtedly an extremely successful one.

Those who have known Philipson for some years have marvelled as much at his physical resilience as at his mental agility. In 1972 he was struck down with a rare and serious illness, necessitating a major operation. The following summer he crossed to France, fortunately having for company Diana Pollock, who was on the first stage of a Grecian journey. Aboard the boat, Philipson was again taken seriously ill. On arrival at Boulogne in great pain, he was admitted to hospital, where he underwent a further serious operation. He was deeply impressed with the skill of the French surgeon and doctors, and of the kindness and patience of his French nurses. While recovering, he painted under their command a delightful series of water-colours, using ideas stemming from his enforced surroundings.

These, not unnaturally, show his imagination operating in a less adventurous way than when in health he had confronted his easel and canvas. Here, if ever, there is a search for peace. Semi-opaque and transparent colours merge images of the hospital room with strange

shadows, suffused in the half-light between recognition and mystery, such as a dreamer experiences newly returned to the brashness of living day. He was determined that every day, there would be a fresh venture. One day the theme would be a postcard sent by well-wishers, another the fruit and flowers in his room; eventually, a young Vietnamese doctor sat for his portrait. All these give off a warmth, a tenderness, a freshness of perception that makes them both touching and satisfying. Rarely can a grateful patient have thanked in a more creative way those whom he regarded as having saved his life. Rarely can a proved master of colourful canvases, of paintings great and small, have shown himself so equally in command of the more intimate chamber-music scale of the water-colour.

Philipson's zest for new opportunities has led him to tackle numerous small-scale ventures. Apart from the Edinburgh Festival poster, already mentioned, he has designed a book plate for the present author, and a series of lithographically produced Christmas cards, evolving with the years into an increasingly complex series of variations on the theme of Christmas, although in this case the development, so to say, is confined to the melody line rather than extended to the rhythm or counterpoint and harmony. Perhaps the most moving is the card designed to mark Christmas 1975, in which the centrepiece of Western man's seasonal myth, Santa Claus, sits musing inside a diamond, delineated with those bands of coloured strips Philipson uses to

64 [37]

demarcate areas of concern [37]. Outside, in the four triangles, fanciful animals suggest the unthinking movement they enjoy within their own habitats. While some of the earlier cards are merely decorative, all are miniature works of art. Limited in edition, those who have been privileged to receive them value them highly.

In one sense, to become Present of the Royal Scottish Academy – which Philipson did in 1973, eleven years after he had first been elected an Academician – could be regarded as the highest public honour other Scottish artists can bestow. There was a time when even English critics admitted that work hung in the Royal Scottish Academy was certain to be both more diversified and more enterprising than that which could be found in London's Royal Academy. In April 1965, for instance, broadcasting in BBC Scotland's programme 'Arts Review', Andrew Forge declared: 'As long as I can remember I seem to have been hearing from old Edinburgh hands that the Royal Scottish Academy is not a bit like the RA in London. And it's not. Even a visitor can see that it does a real job in a real situation; and that it opens its arms far wider, and it has standards which are to do with painting and nothing else. The whole tenor is different – it's "establishment" is not only distinguished, but humane. I have rarely seen such a modestly hung exhibition; no building up of a bastion for the non-member tearaways to break against.'

Yet even at the height of the RSA's supremacy, there were younger artists who felt that the Society of Scottish Artists was where the real spirit of adventure was most welcomed. If today the disparity between Edinburgh and London is less noticeable, that is because the Royal Academy has in recent years adopted a more liberal approach rather than because of any decline in the standards of the work exhibited by its Northern counterpart. Characteristically, Philipson's attitude to his Presidency is that, while maintaining the high standards of the Academy, he is anxious to forge stronger collaborative links with both the Society of Scottish Artists and the Royal Scottish Society of Painters in Water-colours.

He is on record as testifying that, contrary to the belief of some of the rebellious young, the selection committee, now as in the past, does try hard to be as catholic in its approach as possible; just as those responsible for the hanging of the pictures eventually chosen to make up the exhibition do try to achieve the sort of balance that allows each picture to realise its maximum effect.

Now that he has achieved the Presidency of an august body which once provided the setting for the school of Scottish Colourists of which he was a member, it seems fitting to examine briefly his position in relation to its other, and earlier, members. There are those who deny that there was, or is, a Scottish School, a view not held by Andrew Forge who, as long ago as 1962, remarked on an 'Arts Review' programme: 'It can be said without hesitation that, whereas a few years ago there were five or six distinguished Scottish artists with a recognisable Scottish common factor . . . today there is an identifi-

able Scottish School. . . . It's a school that takes to painting as a duck takes to water. Don't mistake me – I don't think ducks are the only admirable birds, or that to be a good painter is quite the same as to be a good artist. An obsession with paint can lead to slickness; a love of colour . . . can end in vulgarity.'

Those associated with Philipson in a school, the effect of which on Forge's eye was one of 'radiance and sensuousness', had one other quality in common: lyricism. With Anne Redpath, the lyrical use of colour was richly decorative, in a peculiarly female way, even in her late church studies. (Incidentally, George Bruce, who knew Anne Redpath well in the last two decades of her life, and who is the author of a companion monograph on her in this series, reports that she once admitted to him that there were only two contemporaries she might perhaps envy – Joan Eardley and Robin Philipson.)

Sir William MacTaggart's lyricism is rich and brooding, Sir William Gillies's a poetic restatement of things as they are. Joan Eardley, indeed, occasionally left her sea-lashed coast scenes, her golden harvest fields, for the social realism of pathetic urban urchins and their scrawled private language of graffiti. But, alone among the group, Philipson's mind shapes the expression of his lyricism. One is always conscious that here is a mind at work, unflinching yet compassionate, concerned not just with sunsets or village fields, or even with deformed children, but with the inherent tragedy of the human dilemma.

Philipson's second year as President of the Royal Scottish Academy coincided with the break-up of his second marriage. His 1975 Exhibition, in the Roland, Browse and Delbanco Gallery in London, shows him to be still advancing upon his older themes; still finding new and exciting statements to be got, in the oil-on-canvas *Cock fight*, and in another smaller similarly-titled picture on leather. Here, too, there were several 'Mexican altar' variants, and one oil and three water-colours titled *High summer*, one of which, no 3 (1974), is reproduced here [*38*]. These breathe the distillation of the rich fullness the physical reality provides. With Philipson, the title comes after the painting, and is meant to be no more than a hint. But Philipson's summers are not the earth's-eye view collages of the later Eardley, with bits of stalk or grass incorporated into the composition. Philipson produces an evocation through the ebb and flow of heightened colour, which the days of summer arouse and slacken, in humans and animals as well as in the skies and growing things.

Significantly, there are pictures entitled *Lovers*: four oils and one water-colour. In these, there appears what it is hard not to interpret as a more direct comment on his personal life – however vaguely any such intention may have been consciously present in his mind, if at all – than he has hitherto allowed himself. In some of these recent pictures, the black-and-white skin theme is touched upon, the black figure lying rejected. In others, such as *Night II* 1975 [*39*] a man and a woman stand naked together, not touching, though their

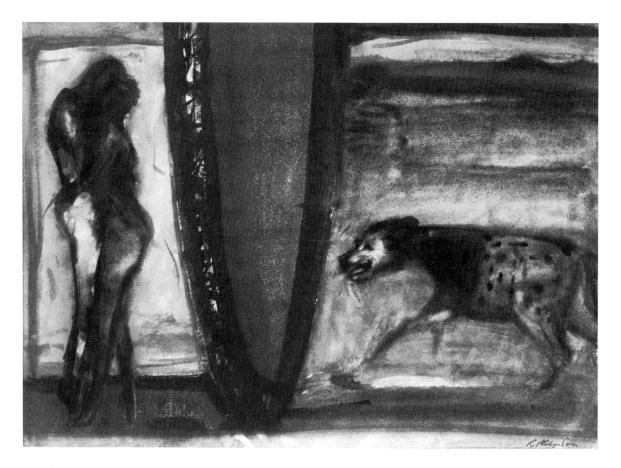

68 [39]

sexuality is defined, while from a neighbouring panel a wolf-creature glowers across at them. Speaking of the 'major concern' of the figure paintings, George Bruce has remarked that while 'the central subject matter might suggest their focus is on sexual intercourse, their concern throughout is human intercourse. Even where the artist indicates clearly that sex has taken place . . . he depicts grief and isolation.' Thus, in number 4 of his sequence *Human kind*, 'the female is no more than a shadow mingling with the ground. The white male sits by her. Above, zebras flicker past with easy animal rhythms. Their kind are in harmony with their natural environment.' As always, however, it is not the literary images, intended or accidental, that create the impact, but the pictorial terms used to communicate something newly expressed about the difficulties and the sadnesses of human relationships.

There was a picture entitled *Zebra* 1974 [*40*] in that 1975 London Exhibition. Philipson's experience of these creatures in real life does not go beyond the zoo. But his horse studies led him to explore the possibilities of this visually more theatrical variant of the species. He has used animal images before, and he tells the story of someone who, after looking at a picture involving animal imagery, remarked to him: 'You know, for a person who doesn't like dogs, that's a pretty doggy-looking dog you've put down there.' Inevitably, the dog and the painter's experience of the dog must interact in the expressionist approach which, it will by now be apparent, forms the lineal direction of

Philipson's style, however much would be ignored by such a simplistic definition.

Now, he is toying with the idea of experimenting with a series of animal paintings. If Philipson does turn to animals, then it may well be that what will have attracted him will once again be another aspect of the untameable, primitive instincts shared alike by animal and man, projected at one extreme through the cock-fight series. Philipson's personal antisyzygy – contrary to what Hugh MacDiarmid used once so vehemently to proclaim, not a national characteristic at all, but one common to the human race – has touched upon cock fights, jousting warriors and the confrontations of war and of love at one end of the scale; at the other, appear rosewindows, confining the fearsome vastness of space to proportions of appreciable wonder, cathedral interiors whose colours sound like chords, and altars that glorify, for many people, the unattainable ideal of the resolution of personal conflict through the self-abnegation of worship. All this will have shown itself still to be capable of new reverberations. For him as for Van Gogh and Kokoschka, the successful painting is the capture of the living moment's burning flame, the revelation of what must pass seized for us to savour and enjoy again at leisure.

However much anyone may dissertate upon this or that artist's technical approach, vital though it must be to the artist himself, in the end what matters is the thing that cannot be defined: the meaning between the lines of a poem, the lift of the heart summoned by

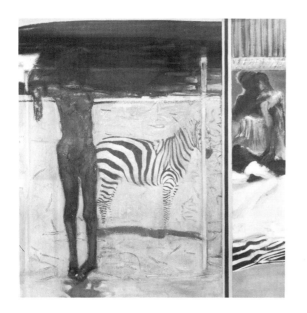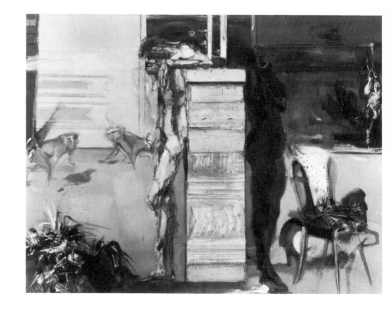

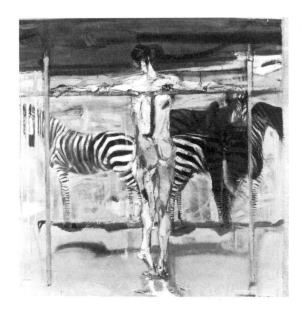

music, the total apprehension of the often indefinable impact a painting demands of eye and mind and heart. While not for a moment decrying the vital importance of craftsmanship, the craftsman whose calculations do not result in this incalculable end is at best a clever tradesman, at worst a commercial hack. The majority of creators in any age are sooner or later found to have been merely craftsmen. I, for one, find in Philipson's achievement the impact of a very considerable artist alive to the dilemmas of his time.

To what extent an artist's work can, or should, be related to the life of his own time outside the necessarily limited confines of his art, is a question about which there are many opinions. The sterile social realism of so much Communist painting, thumping across its politically acceptable 'messages' (often of dubious honesty) in an old-fashioned manner made artificial and absurd by the development of colour photography, is the very negation of what art is about. The human spirit cannot be enriched by paintings enshrining bare situational statements or empty physical gestures, any more than it can draw strength from verses stridently gesticulating State-approved dogmas. Nor, in the view of this writer at any rate, can much benefit of spirit be gleaned from sheer experimentation for its own sake. 'Make it new', Ezra Pound declared, himself now seemingly doomed to become a man more highly regarded for his influence upon other writers than as a major poet in his own right. Novelty is not by itself enough. The pioneers of new techniques have rarely

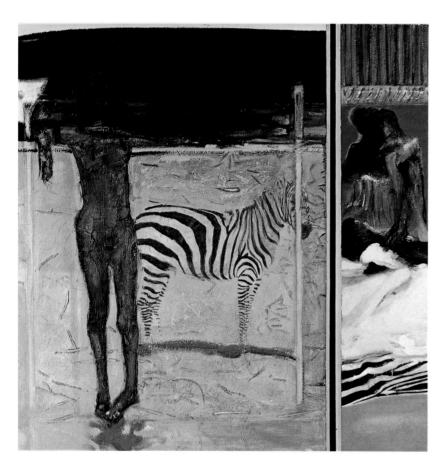

72 [40, *left-hand panel*]

been the artists who have gained notably satisfying, creative advantage out of them. It is those coming after, taking up the new-shaped tools, who are usually best able to concentrate them effectively to rewarding creative purpose. Philipson has taken the existing tools of what he calls the 'rich, traditional vocabularies', and used them to discover new dimensions of visual poetry, new relationships between image and implication.

He himself has said it is his hope that those who come to his paintings with an open mind, without the hamperment of preconceived notions, and give themselves to what they are looking at, may gain in self-knowledge. Colour and paint-textures integrated with feeling, constructional logic and impelled artistic necessity result, in the best of Philipson's work, in the creation of a wildly haunting beauty.

No doubt he still has new images to explore, much that is new and exciting to create out of them. What he has already done, however, not only puts him high in the ranks of late-twentieth century painters in oil, but in the front rank of contemporary water-colourists. Apollo and Dionysus have not yet come to terms in Philipson's work. The final resolution he seeks still eludes him. Let us hope it continues to do so, for it is through the process of search that the vitalising energy of his art is re-charged.

Biography

1916 Born 17 December, Broughton-in-Furness, Lancashire.
Educated at Dumfries Academy.
Trained at Edinburgh College of Art.

1940 Army service in India and Burma.

1946 Teacher training.

1947 Joined staff of Edinburgh College of Art.

1948 Elected member of Society of Scottish Artists.

1949 Married Brenda Mark.

1951 Won Guthrie Award.

1954 First one-man exhibition, The Scottish Gallery.

1955 Elected member of the Royal Scottish Society of Painters in Water-colours.

1958 Exhibition at the Scottish Gallery.

1959 Third prize, John Moores Exhibition, Liverpool.

1960 First London Exhibition, at Roland, Browse and Delbanco.
Appointed Head of the School of Drawing and Painting at Edinburgh College of Art.

1961 Elected Academician of the Royal Scottish Academy.
Exhibition at Roland, Browse and Delbanco.
Married Thora Clyne.

1963 Visiting Professor at the University of Colorado.

1964 Exhibition at Roland, Browse and Delbanco.

1965 Exhibition at The Scottish Gallery (Edinburgh Festival).
Awarded Leverhulme Travelling Scholarship.
Member of the Royal Fine Art Commission.
Elected Fellow of the Royal Society of Arts.

1966 Completed mural for Glasgow airport.

1967 Carghill Award, Glasgow Institute of Fine Arts.
Elected Member of Edinburgh Festival Society.

1968 Exhibition at The Scottish Gallery.

1969 Exhibition at Loom Shop, Lower Largo, Fife.
Group Exhibition 'Seven Scottish Painters', IBM Gallery, New York.
Elected Member of Council, Edinburgh Festival Society.
Elected Secretary of the Royal Scottish Academy.

1970 Touring exhibition 'Cockfight Rosewindow', Scottish Arts Council.
Retrospective exhibition, Dunfermline.
Exhibition at the Scottish Gallery (Edinburgh Festival).

1971 Exhibition at Roland, Browse and Delbanco.
Member of the Scottish Advisory Committee of the British Council.

1973 Exhibition at the Scottish Gallery.
Elected President of the Royal Scottish Academy.
Elected Associate of the Royal Academy.

1975 Member of the Advisory Committee to Lothian Region Council.
Exhibition at Roland, Browse and Delbanco.

1976 Knighted in recognition of his services to art in Scotland.
Honorary Degree of D.Univ. at Stirling University.

Select Bibliography

Die Kunst, April 1958, D. Cleghorn Thomson.
The Listener, 4 October 1962.
The Scotsman, 20 May 1961, Sydney Goodsir Smith.
The Scotsman, 16 June 1969, Edward Gage.
Scottish Art Review VIII, 1961, T. Elder Dickson.
Scottish Field, May 1965, Emilio Coia.
The Studio, October 1962, T. Elder Dickson.

Three Scottish Painters (Maxwell, Eardley, Philipson)
film, 1963, Templar Film Studios, Scottish Com-
mittee of the Arts Council, and British Council.

The artist at work
on *Ascension and Crucifixion* [*19*].

Public Collections owning Works

ABERDEEN
 Art Gallery
CARDIFF
 National Museum of Wales
DEPARTMENT OF THE ENVIRONMENT
DUMFRIES
 Gracefield Arts Centre
DUNFERMLINE
 Carnegie Trust
EDINBURGH
 City Arts Centre
 Moray House College of Education
 Queen Margaret College
 Scottish Arts Council
 Scottish National Gallery of Modern Art
 University
GALASHIELS
 Scottish College of Textiles
GLASGOW
 Art Gallery and Museum
 Lillie Art Gallery, Milngavie
 University
KIRKCALDY
 Museum and Art Gallery
LEEDS
 City Art Gallery
LIVERPOOL
 Walker Art Gallery
MANCHESTER
 Whitworth Art Gallery
MIDDLESBROUGH
 Art Gallery

The artist at work
on *Threnody for our time* [*31*].

NEWCASTLE UPON TYNE
 Laing Art Gallery
NOTTINGHAM
 The Castle Museum
PAISLEY
 Museum and Art Gallery
PERTH
 Art Gallery
SOUTHPORT
 Atkinson Art Gallery
STIRLING
 University
SUNDERLAND
 Museum and Art Gallery
USA
 North Carolina Art Gallery and Museum
 University of Colorado, Boulder

Bookplate, done for the author by the artist.

List of Illustrations

The publishers are grateful to those individuals and institutions listed below for permission to reproduce works in their possession. Dimensions are given in millimetres and inches, height before width. Unless indicated otherwise, the paintings are in oil.